The Easy Guide to
PAINTING WATER
in Watercolour

First published in 2024
Search Press Limited
Wellwood, North Farm Road,
Tunbridge Wells, Kent TN2 3DR

Text and artwork copyright © Stephen Coates 2024

PHOTOGRAPHY
Stephen Coates: on pages 10, 11, 96, 108
Copyright © Stephen Coates 2024

Andrew Locking: pages 12, 29, 41, 50, 84 (R), 88
Copyright © Andrew Locking. Reproduced with kind permission.

Jim Mackenzie: page 84 (L)
Copyright © Jim Mackenzie. Reproduced with kind permission.

Mark Davison: all remaining photographs
Copyright © Search Press Ltd. 2024

Design copyright © Search Press Ltd. 2024

ISBN: 978-1-80092-106-1
ebook ISBN: 978-1-80093-097-1

The Publishers and author can accept no responsibility for any
consequences arising from the information, advice or instructions
given in this publication.

SUPPLIERS
If you have difficulty in obtaining any of the materials and
equipment mentioned in this book, then please visit the
Search Press website for details of suppliers:
www.searchpress.com

BOOKMARKED HUB
An extra project is also available to download free from the
Bookmarked Hub. Search for this book by title or ISBN: the files
can be found under 'Book Extras'. Membership of the Bookmarked
online community is free: www.bookmarkedhub.com

ABOUT THE AUTHOR
You can find information about the author and his work on the
following websites:
– his personal website, www.coatesart.co.uk
– his YouTube channel, @StephenCoates

PUBLISHERS' NOTE
All the step-by-step photographs in this book feature the author,
Stephen Coates. No models have been used.

MIX
Paper | Supporting
responsible forestry
FSC® C136333
FSC
www.fsc.org

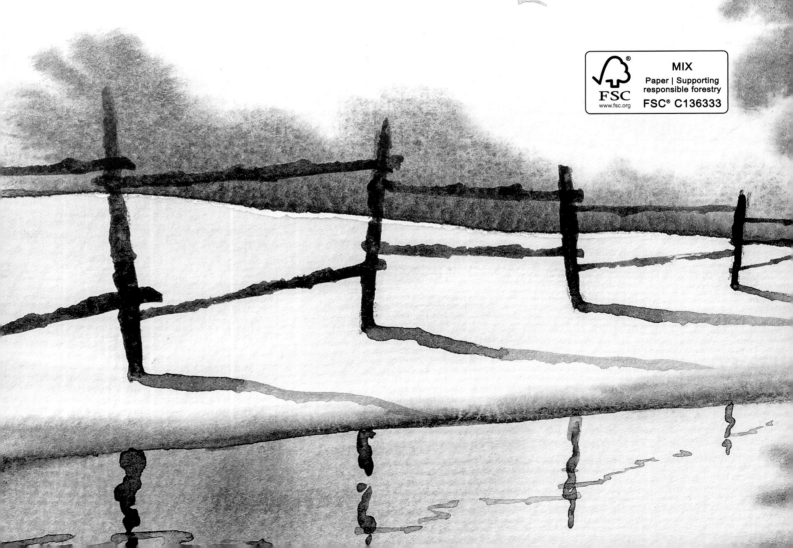

The Easy Guide to
PAINTING WATER
in Watercolour

Stephen Coates

SEARCH PRESS

Contents

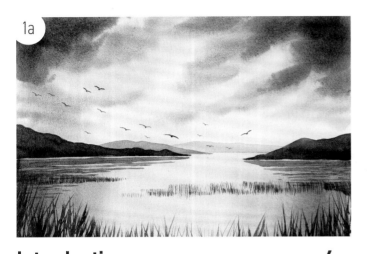

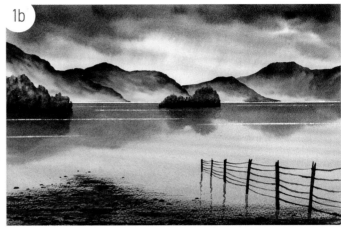

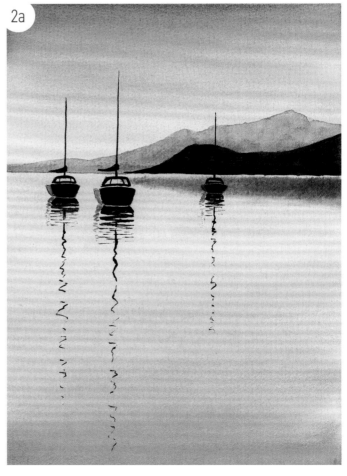

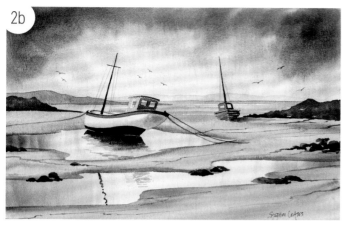

2b

3

4

5

6

Introduction

My love affair with water most likely started as a boy when I took up fishing. Many visits to the riverbank, starting at the crack of dawn, have left a lasting impression on me and still gets me excited to this day!

I think most people would agree that there is something very special about water. For some it is the coast with its wild seas and beautiful beaches, for others it might be a lake, river or canal. Just the sound of a babbling brook or a cascading waterfall can be incredibly therapeutic. Being at the waterside seems to provide its own unique brand of contemplation and as an artist, I wanted to translate these emotions into my work.

I desperately wanted to understand how to represent water effectively in my paintings. Over many years I have studied the effect of light on water, and experimented with different painting techniques based on my observations. The surface of any body of water will reflect light into our eyes and my research has shown that reflections can vary enormously depending on the surface condition of the water. We know water exists in a scene because of the reflections, but our attention is usually dominated by the subject above rather than what is happening in the water.

I would always advise an artist to study and practise techniques before committing to a final painting. I have included an array of photographs and exercises for you to consider and try yourself. There are also several manageable painting projects for you to complete. This book brings together all the aspects of reflections that I have studied and I hope that by sharing this with you, it will inspire you to paint water with more confidence and with much better results.

Good luck!

Best wishes,

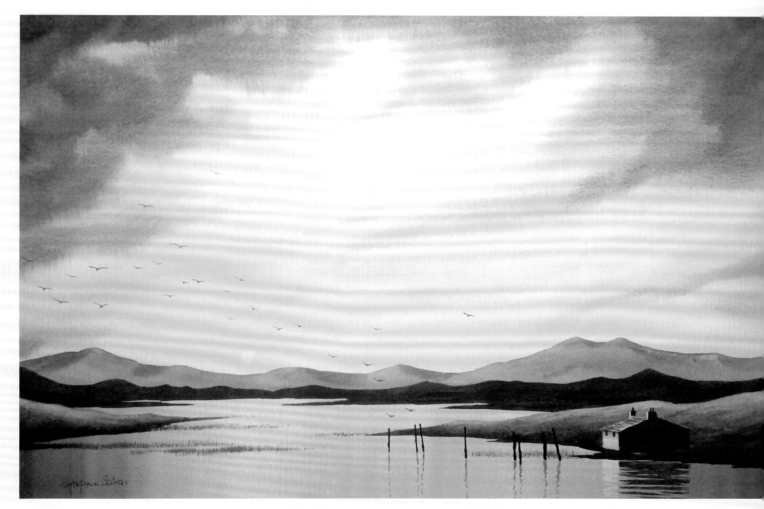

Sunset on the Lough

55 x 35cm (22 x 14in) Bockingford NOT 425gsm (200lb)

Using just raw sienna, burnt sienna and a plum mix made from ultramarine and light red, this painting features a tranquil sunset with an old white boathouse by the side of an Irish lough. The soft white line in the water is the reflection of the setting sun and is created during the process of painting the shine in the lake. The whole area of the water is wet first with a hake then the lines of colour are brushed in, with a long white vertical space a third of the way in from the left (this technique is explained on page 33). The white face of the house and the reflection are 'lifted out' after the area of water has dried (see page 23).

Planning

All three of the important considerations before embarking on a painting begin with the letter P: **planning**, **preparation** and **practice**. This is very convenient and makes it much easier to remember.

Let's have a look at these in a bit more detail, and examine why I have made each of these stages a 'must-do' before starting a painting.

1. PLANNING

It is always advisable to spend some time planning a watercolour painting. Unlike acrylic and oil paints, there are things which are simply not possible with watercolours, the most obvious of these being the inability of lighter watercolour pigments to lie on top of previously painted dark ones. Any lighter colours must be applied first; then these can be overlapped or covered by darker ones as you progress through the painting. For this reason, an order of play should be carefully thought out.

The simple fact with watercolours is that we have a short amount of time to get the paint on before it starts drying – this is especially troublesome when painting larger areas such as a sky. Whenever I start a new painting, I always produce a pencil sketch first. I do this for two reasons. First, as there is little time to get the paint on, a sketch helps me to familiarize myself with what I am about to do. Second, with a sketch I can see if the shape, composition and balance of the painting is right. Sometimes I include the shape of the clouds in my sketch to ensure there is some depth and perspective in the whole composition. I never paint directly from a photograph, preferring instead to work from a prepared sketch.

2. PREPARATION

Crucial to the whole process of getting the paint on in time is the preparation of the palette. For example, once work on a sky has started, it must be concluded very quickly. If the palette has not been prepared correctly, and if there are any delays after the painting has begun, the water will evaporate; by the time the artist gets back to painting the sky, it may well be too late and have started to dry!

3. PRACTICE

Surely everyone understands that practice is required in order to be really good at something. Proficiency through practice applies to everything – be it sport, playing a musical instrument or cooking, to name a few examples. Watercolour painting is no different, and the only way to get a better understanding of this difficult and troublesome medium is through repetition. Furthermore, before adding anything to a painting, I recommend you practise the technique first – especially if you have never tried it before. It helps to ensure that the paint has been prepared correctly, and gives the opportunity for you to have a 'rehearsal' before the real thing. A good example of this is when you add finishing touches such as human figures or birds. I would always recommend painting a few first on a separate bit of paper before committing to the painting.

Water and reflections

To create the illusion of a body of water in a painting, it is important to observe how reflections behave.

REFLECTING LIGHT

As we all know, a reflection tends to be visible on any smooth shiny surface. Water is no exception, of course; it has a surface tension – or 'skin' – that is glossy, and therefore tends to reflect light. But unlike a mirror, which reflects all of the light that reaches its surface, water also lets some of the light pass through it. It is transparent as well as reflective, just like glass.

When we look through a window during the day, our reflection is virtually invisible due to the light passing through from the other side. At night, however, our reflection is much more visible because of the lack of light outside. This same phenomenon applies to a body of water such as a lake or river. Many lakes, lochs and fjords are so deep that the light doesn't penetrate to the bottom. This gives the impression that the water is black, and so causes reflections to be more intense. Conversely, shallow water will be less likely to produce strong reflections because of the visibility of the silt, rocks or weeds lying just below the surface.

Any body of water – from a raindrop to a puddle, from a canal to a deep loch, from a river estuary to the open sea – will reflect light. Reflections that bounce off the surface of water are quite visible to us, but they are not always obvious. However, it is their very existence that helps us determine that what we are looking at is, indeed, water.

REFLECTIONS, NOT SHADOWS!

Many people confuse reflections with shadows. The two are completely unrelated. A shadow is cast when something blocks the path of light, therefore it can lie in any direction, depending on the position of the source of light.

All reflections on a body of water can be observed only directly below the subject. Shadows are rarely visible on water, although they may be evident when it is murky and full of silt, in which case a shadow might appear as it is cast across the muddy particles in the water.

Shadows in the Snow
28 x 19cm (11 x 7½in), Bockingford NOT 300gsm (140lb)

In the painting, right, the shadows of the large tree and fence posts are clearly laid across the snow away from the source of the sunlight, while the unrelated reflections in the water lie vertically below the subjects.

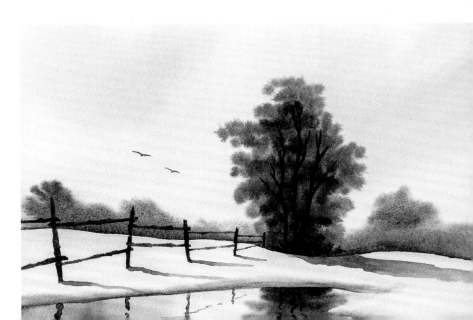

HOW REFLECTIONS BEHAVE

When painting water, you need to think about light and the way it reflects off the surface. Put simply, visible light is a beam of energy that travels in a straight line. It can be blocked, diverted or even bent in extreme conditions.

When we see an object that is above the surface of the water, the light from that object passes directly into our eyes in a straight line through the air. However, light from that object also travels down towards the surface of the water and bounces off the surface. Therefore, reflecting light will vary enormously according to the condition of the surface of the water as well as the aforementioned depth. Understanding and observing these variations is really beneficial to the artist. Let's take a look.

For a bit of fun, I wanted to show you just how much reflections can vary. To do this, I set up a black seed tray in my garden and filled it with water. I then placed a white post at the far side and deliberately created a variety of disturbances on the surface of the water, which you can see below. These show how various conditions can affect the reflection of an object.

STILL WATER

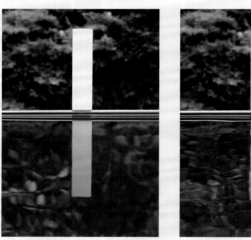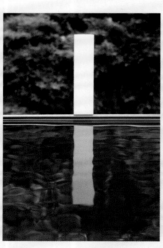

In the left-hand example, the water is completely calm and therefore produces a reflection exactly as you would expect from a mirror: it's a perfect inversion of the post, and is exactly the same length.

In the right-hand image, the surface of the water is mildly undulating. You can clearly see that the reflection has grown slightly longer but remains mainly intact apart from a few wobbles down the sides.

RIPPLES

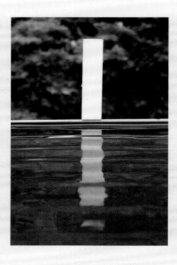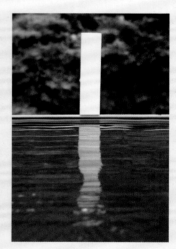

Ripples travel across the water, usually from a single source. A single disturbance would typically send out ripples with a wide equal space between them. However, a duck flapping around on the water, for example, would emit a series of more narrowly spaced ripples.

Either way, the result is clear in these images. The reflections now have a series of horizontal breaks where the white light is unable to reach our eyes due to the angle of the water immediately beyond the ripples. Note how the width of these gaps widen towards the water closest to our eyes at the lower part of the reflection due to natural perspective. You can also see how the width of the reflection can vary along its length.

SWELLS AND UNDULATIONS

 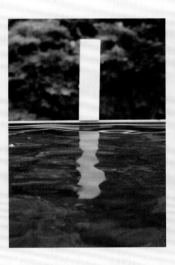

When the water is constantly disturbed by a variety of sources, it tends to bob around randomly as all the ripples converge into a swell, a bit like those on the sea. This can throw the reflection around quite a bit, resulting in wider gaps, enhanced wobble and, more often than not, a greater length.

Interestingly my camera captured a rare moment when the reflection was actually shorter than the post!

WIND DISRUPTION

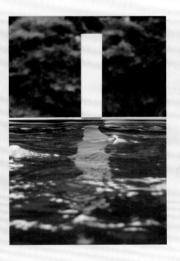 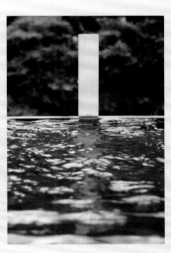

The wind often rattles across water, disturbing the surface to the extent that reflections become indiscernible. I was unable to disturb the surface of the water enough in my set-up on these pages, but I had a good go!

As you can see in the two images, the reflection has almost disappeared. This is due to the light from the post, along with many other surrounding objects, bouncing off the surface of the water in completely random directions.

SURFACE CONDITIONS

SHINING WATER

When the surface of the water is on the move, regardless of what is causing it, the various colours in the sky and the land above do not reflect precisely. Instead, the collection of colours and shapes cast reflections off so many parts of the water that they end up forming long, soft vertical stripes of reflected light, as you can see in the top photograph. This single phenomenon is what gives water a 'shine'. Elongated vertical streaks of light will feature in most reflections. All you have to do is observe it and then try to represent it as well as possible. In my view this is a really important feature and we will be re-creating it often in the exercises and projects that follow in this book.

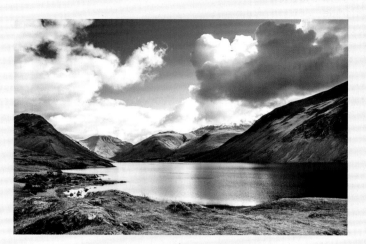

PARTIAL REFLECTIONS

Wind doesn't usually blow at a constant speed. More often than not it pulses in strong, irregular gusts and often occurs in patches. The effect of this can be clearly observed in the middle photograph. The calm water is creating strong mirror-like reflections in the lower area of the lake. A second or two earlier, these reflections would perhaps have covered the whole surface. However, in the distance an isolated gust of wind has whipped across the surface of the water and eliminated the reflections, resulting in a line running all the way across. This strip of light, caused by the wind, often creates a sparkle as well and is often depicted in paintings. It can really add a sense of depth to a painting but also provides a convenient division between the mountains and the reflections. Many artists choose to place a narrow strip of light along the water's edge.

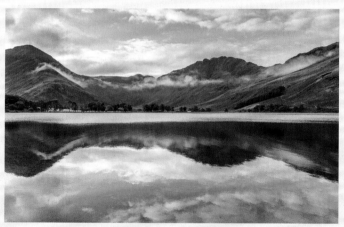

BLURRED REFLECTIONS

A steady and gentle wind can often blow across the surface of the water. This produces a shimmer across the whole surface, causing the reflections to blur. Providing there are no ripples or swells present, this soft blurring effect can be extensive and quite enchanting. As you can see in the bottom photograph, the reflections of the mountains and the clouds in the water appear blurred. To replicate this with watercolours, we must use a wet-into-wet method; more on that later.

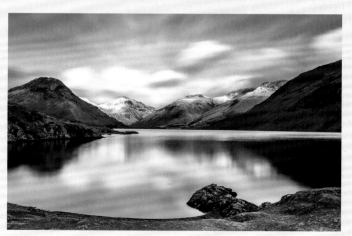

REPRESENTING REFLECTIONS WITH PAINT

Having studied reflections and how they can vary, I wanted to show you a few painted examples. When the artist has a full understanding of all these different types of reflections, it becomes a matter of choice as to which ones to represent in a particular painting. Reflections in photographs can be very complicated, so simplification is recommended.

In all three of the sample paintings below, I wet the paper first then swept raw sienna through the centre of the paper. While this was still wet, a plum-coloured mix (made with ultramarine and a little light red) was washed in smoothly, both from the lower area upwards and then down from the top. The boats and reflections were painted with a really strong version of the plum mix.

The examples below are worthwhile practice exercises that you can try yourself.

Fig. **a** shows completely calm water. When the graded wash was completed, I left it to dry. I then used the strong plum mix to paint the boat as a dark silhouette set against the background sunset. When there is calm water, the reflections are a pure inverted mirror image of the boat with no distortion at all. Therefore, I was very careful to get the placement and shape of the reflection absolutely perfect; this is actually quite tricky to achieve.

Fig. **b** features water with gentle ripples. I drifted a few horizontal lines of the plum mix into the lower part of the wash while it was still wet to represent a few ripples. Painting the reflections for this study was much easier, as moving water means that their shape can be more fluid. I painted the area directly under the hull of the boat quite densely and then gradually broke this up into a series of lines, increasing the space between them as I moved down. I also gave the reflection of the two masts a lovely 'wobble'. Note also that I have extended the length of the reflections.

Fig. **c** depicts a gentle breeze across an otherwise calm surface. The soft blurring effect was achieved by painting the whole reflection while the initial wash was still damp. This meant the boat couldn't be added until the wash had dried. Using this method to create blurred reflections before painting the subject is quite common, but does feel a little awkward.

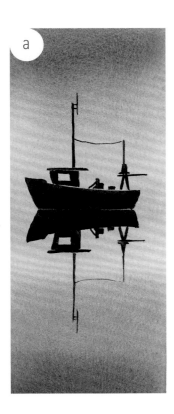
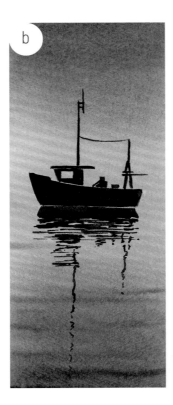
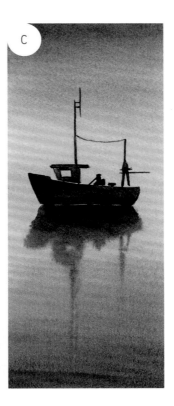

Understanding paint

It would be fair to state that watercolour paint differs enormously from any other medium. In my view, it is vital to examine what the differences are in order to understand why watercolours should be approached in a particular way. Allow me to explain:

When you look at other paints such as oils or acrylics, they contain an agent that hardens the paint as it dries. Once set, the paint is permanent. Oils and acrylics are also opaque, which means that the paint is thick and doesn't let light through. This gives the artist the luxury of over-painting without the paint underneath showing through. Furthermore, these solid paints don't flow or move on the surface once they are applied. The paint can be easily manipulated while it is still soft, and the slow drying time gives the artist plenty of time to get the paint into position.

In contrast, watercolour paint is unique in that the **paint pigments are suspended in water**, and don't set or cure as the water evaporates. A little gum arabic is added to the paint by the manufacturers, which acts as a binder and helps to slow down the drying time, but there is no drying agent or a chemical reaction taking place. When watercolour paint is spread out on the paper, the water just evaporates naturally and the drying process begins immediately.

Watercolour paint particles 'shuffle' around in the water, creating movement, natural blending and granulation. However, this happens only for a very short time while there is enough 'active' water present. The water rapidly disappears, and the paint particles nestle down onto the paper, gradually taking up a permanent position. The movement and form of the paint at this drying stage of the process should be a natural one created by the water, rather than the paint brush.

> **KEY POINT**
> The initial placement of the paint is done with a brush. The final resting place of the paint is determined by the active water.

THE TWO-MINUTE RULE

Due to the speed at which watercolour paint dries, the placement of the paint should be done very quickly while there is still active water on the paper; once the water begins to evaporate, the artist should dispense with the brush and allow the paint to develop naturally. Only then will there be a chance of a decent result.

Leaving the paint to 'do its thing' is very tricky, not because it's hard technically but because it's hard mentally. We are human beings, and we just can't help ourselves – we just have to fiddle and dab away at the paint as it is drying because we can see it is not quite right. The paradox here is, if the wash is not developing quite as planned within a couple of minutes of finishing with the brush, it definitely cannot be improved by picking up the brush again. Fiddling with the paint further will almost certainly make things worse! However (and this is where the paradox comes in), most of us are convinced that we are capable of an improving touch. It is not actually we who are incapable, it is the property of the paint that prevents it! Understanding this is the key to painting successful washes.

I recommend that the **paint should be fully applied within two minutes**, even less if possible. In fact, the quicker the better. If it can be done in one minute, the result is likely to be better still. The paint should then be left to form naturally, and this may take anything between a further two to five minutes. This will depend on how much water has been applied, the type of paper used, the air temperature and the humidity level.

During the natural drying process, the paint might reach a really satisfactory position and the artist may not want it to develop any further. The use of a hairdryer at this point will give an almost instant fix. However, care must be taken when drying a wet wash with a hairdryer. If the paint is still very wet and loose, a blast of hot air could easily displace the paint and push it around the paper. This could spoil the wash or create unwanted watermarks.

KEY POINT
Continually fiddling with a wash as the paint dries will utterly ruin it as dry streaky brush marks appear and everything becomes patchy.

CONSISTENCY AND MIXING

Watercolour paints usually come in two basic forms. They are either dried in a block, referred to as a 'pan', or dispensed from a tube. Paint in a tube is soft and can be easily squeezed out in larger quantities. The choice of which to use depends very much on the style of the painting. Many artists have both available in their kit.

Dried blocks require water to get the pigment active and the paint is then transferred onto a palette or into a well. The consistency or thickness of paint needs to vary according to the task. Quite simply, the more water added to it, the more fluid and transparent it becomes. Watercolour paint must be fluid in order for it to flow out of the brush, but the level of fluidity or consistency of the paint is crucial.

The consistency of paint on the palette is very important when adding one colour to another on the paper, often referred to as 'wet-into-wet' or 'charging'. Many people pay little attention to this, but this is where control can be lost in the process. If the secondary colour added to the initial wash is too wet, the paint will spread out in an uncontrolled manner, and all the pigments will merge together and develop into a single, over-diluted mix. The initial area of paint would normally be abundant and quite loose in consistency. Any secondary colours should

therefore be much thicker so that the pigments disperse in a more controlled way, giving definition to the shapes created. These secondary shapes (such as clouds in a sky) can then have substance, and remain in position while settling a little and softening gently around the edges.

That said, if the secondary colours are too thick, they will barely disperse at all, leaving hard, lumpy shapes. Also, if the initial wash is far too wet, even thick secondary colours could disperse too readily. So, you see, the consistency of the paints is really important and requires a lot of trial and practice to get it right.

These factors are precisely why my preference is to use tubes. Once the paper is wet, all the colours added need to be of a thicker consistency. With dried pan blocks, a lot of water and scrubbing with the brush is required to extract the paint. It is extremely difficult to get this paint thick once it has become activated with water. I've found the only way to do this is to add some water to the pan and let it soak in for about 20 minutes. This softens the paint and it is then possible to extract thicker paint from the pan. Personally, I find this quite a faff, so in my view tubes are far easier and more suitable for painting.

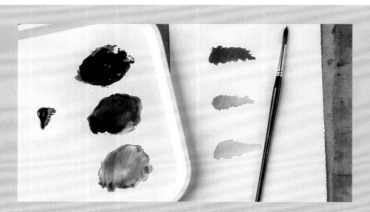

▲ Here, I have created a plum colour by combining ultramarine and light red. The uppermost mix on the palette has only a small amount of water and is stirred until it is quite thick. I then transferred some of this mix onto two further areas below and added successively more water to each one, so I had three different consistencies of the same mix. You can clearly see the difference in transparency of the three mixes and the resulting swatches on the paper at the side.

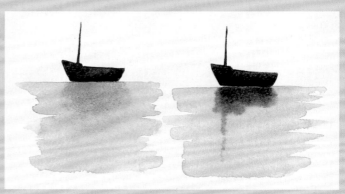

▲ Throughout the book there is a significant amount of wet-into-wet blending, so it's important to add the right volume of water to the paint to help keep control of the blend. The exact consistency of the paints is not quantifiable, so learning just how much water to add will require plenty of practice and experimentation.

In the examples above, the reflection of the boat has been added to the water while it is still wet. In the left-hand example, the secondary colour was diluted with water a little too much and so the final reflection has very little substance. However, in the right-hand example the secondary colour was much thicker; this results in a darker reflection with a more distinct shape.

THE PALETTE AND MY WORKING RULES

Before we take a look at the projects later in this book, I will detail the typical process of preparing for a painting. Through this, I would like you to see how I go about setting up and how I check the correct consistency of the paints prior to starting a piece of work.

1 With a large expanse such as a sky, I always wet the paper first. The amount of water on the paper is a matter of experimentation and practice. For smaller areas where a wet-into-wet technique is often used, the initial colour is applied first and should have a loose consistency. There should be enough paint on the palette to achieve this first stage.

2 All secondary colours added should have a thicker consistency, often straight from the tube, especially if you are painting a sky. For wet-into-wet blending, the consistency of the secondary colour should be prepared and tested, ideally on a scrap of the intended painting surface.

3 If a mix is required, the paints are stirred together using a small round brush and enough water to achieve the required consistency (see stages **a**, **b** and **c**, right).

4 Other colours which do not require mixing are placed on the palette with adequate space between them to prevent them running into each other. Of course, you might prefer to use separate wells or a palette that divides into several sections.

5 The palette is now ready! I never embark on a painting until the palette is fully prepared, tested and ready to go.

NOTE ON CONSISTENCY

It is often difficult to see the true colour of thick paint, so I always transfer a little of the mix to a clear section of the palette and add some water to dilute it. I can then see how it will look once it is introduced to the water, which will be applied to the paper at the first stage. The pre-wetted paper will automatically dilute the mix in the same way. I often paint a little onto a bit of dry test paper to double check the result.

MY COLOUR PALETTE

To complete the paintings in this book I've only used the following colours: ultramarine, light red, raw sienna, burnt sienna, burnt umber, cerulean blue and lemon yellow. It is truly amazing how many variations of colour can be achieved with a limited palette.

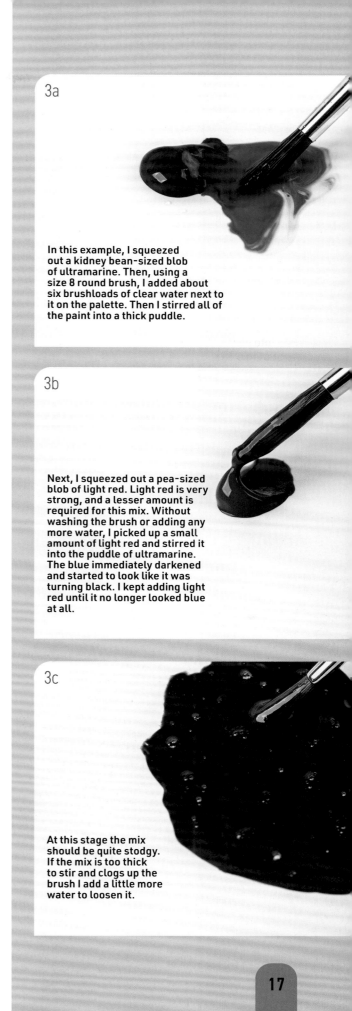

3a

In this example, I squeezed out a kidney bean-sized blob of ultramarine. Then, using a size 8 round brush, I added about six brushloads of clear water next to it on the palette. Then I stirred all of the paint into a thick puddle.

3b

Next, I squeezed out a pea-sized blob of light red. Light red is very strong, and a lesser amount is required for this mix. Without washing the brush or adding any more water, I picked up a small amount of light red and stirred it into the puddle of ultramarine. The blue immediately darkened and started to look like it was turning black. I kept adding light red until it no longer looked blue at all.

3c

At this stage the mix should be quite stodgy. If the mix is too thick to stir and clogs up the brush I add a little more water to loosen it.

Brushes and brushing techniques

All parts of a painting should be completed quickly before the paint starts to dry. This is manageable with small areas but becomes problematic for larger ones. Generally, watercolour artists will use specially selected brushes to paint more expansive areas such as water or a sky and then revert to a more traditional range for everything else in the composition. The choice of brushes is a personal one, of course, but in my view it is necessary to have a wide selection of sizes, shapes and hair type so that the right brush for each technique is available.

BRUSHES

SYNTHETIC VS. NATURAL HAIR

Most synthetic (man-made) hair is relatively firm and the fibres are quite straight. A synthetic brush head doesn't swell to allow water in as readily as a finer, natural-hair brush. The delivery of water onto the paper is also more plentiful with natural hair and, in my view, allows the artist to work more quickly and with delicacy. The firmness of synthetic hair tends to create more lines and hard edges, which makes it more difficult to achieve a smooth finish. With that being said, at the time of writing there are some lovely new synthetic hairs available. For example, my own 'Spearhead' range is made with really fine, slightly wavy synthetic fibres that emulate natural hair very closely.

However, for more expansive washes, my personal choice is goat hair, which is available in both round mops and hakes. I know plenty of other artists who use large, round squirrel mops for painting larger washes.

There is, of course, the ethical argument about the use of natural hair; this is understandable and so it is down to the individual to make that choice.

FLAT BRUSHES

Flat brushes are pressed into a chisel shape and are great for a variety of jobs.

Synthetic flat brushes, also known as 'one stroke', produce brush strokes that tend to be angular and sharp. The hairs are straight and firm, which means they hold their shape while being used to apply or scrub away paint. I like to use a 6mm (¼in) flat and a 12mm (½in) flat.

Most flat brushes don't hold much water, especially synthetic ones. However, the hake (which has a flat profile and is typically made with goat hair) swells to let in copious amounts of water. The soft hair also provides a full flow of water onto the paper with barely a touch. The hake brush is of Japanese origin and, as I am often reminded, should be pronounced 'hacky' or 'hah-kay'. However, in the UK it tends to be pronounced as it is spelled, and therefore sounds like a fish!

The bigger the painting area, the bigger the brush should be in order to comply with the timing target. I use three sizes of hake: a large, which is about 50mm (2in) wide; a medium, which is about 25mm (1in) wide; and a smaller version called a Mini-Hake, which I have especially made for me – it is about 20mm (¾in) wide and is manufactured with a traditional flat metal ferrule. All three are products by ProArte, and they are pictured on the facing page.

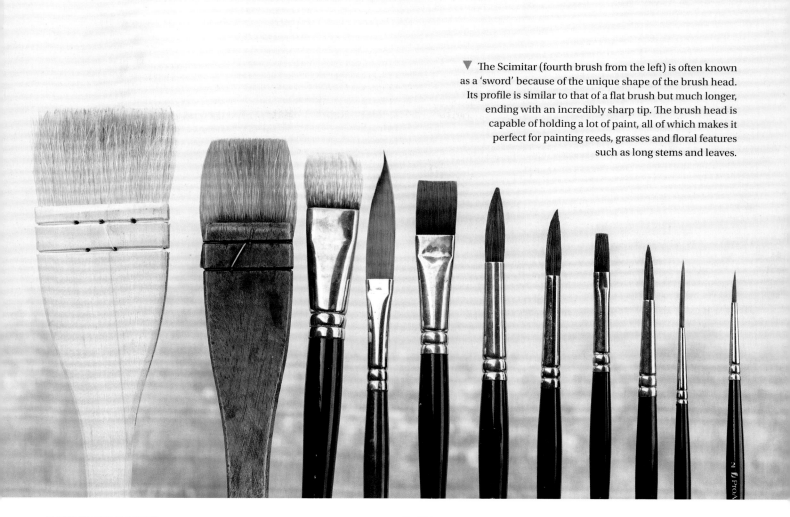

The Scimitar (fourth brush from the left) is often known as a 'sword' because of the unique shape of the brush head. Its profile is similar to that of a flat brush but much longer, ending with an incredibly sharp tip. The brush head is capable of holding a lot of paint, all of which makes it perfect for painting reeds, grasses and floral features such as long stems and leaves.

ROUND BRUSHES

Most artists will recognize and use the round brush. As the name would suggest the brush head has a round profile and usually tapers to a fine point. The size of round brushes is denoted by a number although this does not relate to any recognizable measurement. Basically, the smaller the number, the smaller the brush. For example, a size 1 brush is tiny, sizes 8–12 are considered medium in size, and then brushes go all the way up to a size 24, which is around 2cm (¾in) wide. They are all available with synthetic or natural hair, the latter being softer and more capable of holding water.

EXTRA BRUSHES

The exercises and projects in the book feature a range of brushes some of which have been described in detail on the facing page. This is the full list of all the brushes used, and reflects the order shown in the photograph above.

- 'Stephen Coates' large hake by ProArte
- 'Stephen Coates' medium hake by ProArte
- 'Stephen Coates' mini hake by ProArte
- 'Stephen Coates' medium Scimitar by ProArte
- ProArte series 106 flat, 12mm (½in)
- 'Stephen Coates' size 10 Spearhead round brush by ProArte
- 'Stephen Coates' size 8 Spearhead round brush by ProArte
- ProArte series 106 flat, 6mm (¼in)
- 'Stephen Coates' size 6 Spearhead round brush by ProArte
- ProArte series 103 rigger, size 2
- ProArte Prolene series 101 round brush, size 2.

BRUSHING TECHNIQUES

Most people will pick up a paint brush and hold it like they hold a pen. I've seen many people hold a brush at the furthest tip of the handle, whereas others will clamp down on the ferrule right next to the brush head. I'm not going to suggest that there is a right or wrong way, because we are all different and the brush should feel comfortable in our hands. However, there are some gestures and movements that are common to us all which I think are worth pointing out and could prove useful.

MOVEMENT

There are three joints on our arms: the shoulder, the elbow and the wrist. Movement can come from any of these joints or any combination of them. The wrist is unique in that it can turn in any direction. It is almost a universal joint. When a fast broad wash is applied, it is better to hold the wrist and elbow in a locked position and move the whole arm across from side to side, working only from the shoulder. This helps keep the brush upright and ensure a smooth transition. However, there are other occasions when shorter brush strokes are required; for these, you might hold the shoulder and rotate the wrist instead. A turn of the wrist will bring the brush head off the paper very quickly, leaving a tapered mark. One other thing: it might be helpful to stand up when performing broad washes. The movement of the shoulder is greatly enhanced when you are applying a wash in a standing position.

PRESSURE

Unlike when using a pencil or a pen, very little downward pressure is required with a paint brush. Watercolour brushes are made with softer hair and the paint will naturally flow out of the brush head as soon as it comes into contact with the paper. It is usually better for a brush head to be full of paint because the resulting flow will be longer and smoother. Only the very tip of the brush needs to touch the paper for the paint to start flowing, and the movement of the brush will leave a trail behind it. Forcing a brush downwards will splay open the hairs and shed all of the paint very quickly. It is much easier to control watercolour paint with a very light touch.

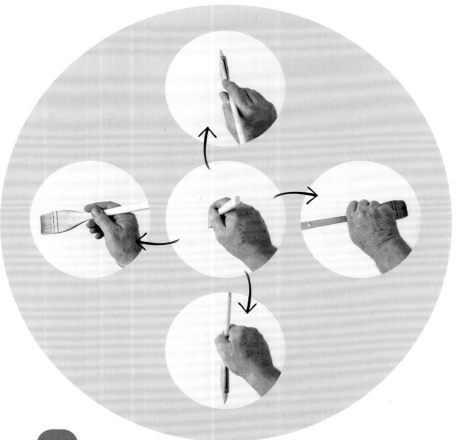

◀ **Universal rotation:** With the whole arm and fingers in a static position and the brush held naturally, the wrist can turn up and down and from side to side. It is very important to be able to alter the angle of the brush quickly, and this is done by using the wrist.

ANGLES AND BRUSH STROKES

It is useful to understand that there is a wide variety of brush strokes that can be achieved by simply changing the angle at which the brush is held to the paper.

In all the examples shown right, a size 8 round brush is used and the brush head is full of paint, allowing the paint to flow freely onto the paper.

In Fig. **a**, you can see that the brush is held at an approximate 60-degree angle, which is generally the same angle at which most people would hold a pen or pencil. It is mostly the tip of the brush that is in contact with the paper, and therefore a narrow mark is produced (Fig. **b**).

In Fig. **c**, the angle of the brush to the paper is around 30 degrees. The tip is still in contact with the paper along with some of the side of the brush head. This results in a wider mark (Fig. **d**).

There are some techniques that require the brush to be held at a much lower angle. Holding the brush at such a low angle is a little tricky so you might want to experiment with the methods in the photographs on the right. Try gripping the brush normally and rotating your hand round until your thumb touches the paper (Fig. **e**).

The alternative is to pick the brush up with your thumb and fingertips with the whole of your hand above (Fig. **f**). The brush is being held almost parallel to the surface. Furthermore, the tip is no longer touching the paper but, instead, more contact is being made by the side of the brush head (Fig. **g**).

Holding the brush this low is necessary when utilizing a technique generally known as 'dry-brush'. The brush is used with less water than usual to restrict the flow of paint. Only the bumps on the paper are caught with the brush, and you should avoid allowing the paint to flow into the depressions of the paper. The result is a brush stroke with a broken texture (Fig. **h**). See pages 85–87 for more information about the dry-brush technique.

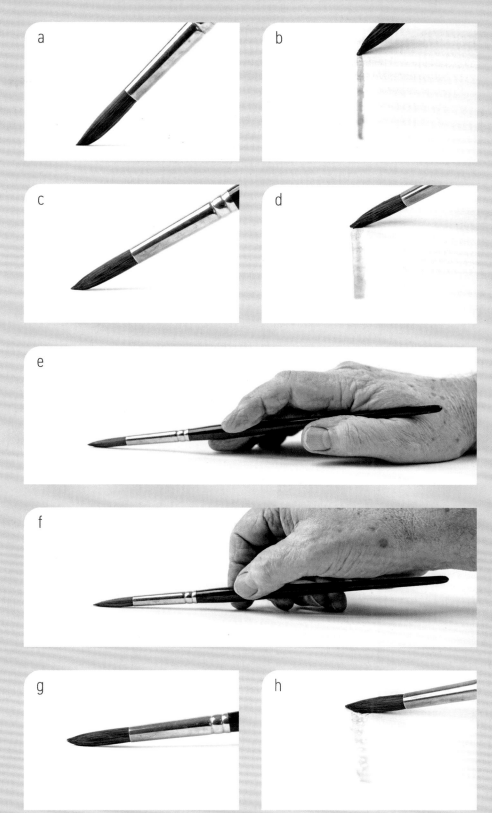

USING A FLAT BRUSH OR HAKE

BROAD WASHES

Broad washes can be applied with any flat brush. However, I recommend the hake for more expansive areas such as in a sky (see page 18). To apply broad washes, the brush should be held in a way so that the full width of the brush tip is in contact with the surface at all times (Fig. **a**). This will result in a parallel brush stroke all along its length (see Fig. **b**). If the brush is swept across at an angle or too much pressure is applied, the brush head will distort (Fig. **c**).

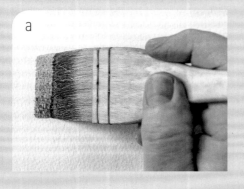

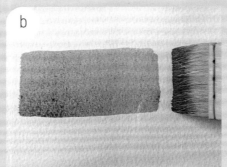

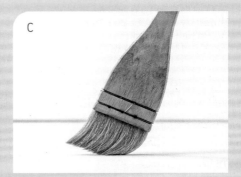

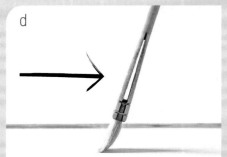

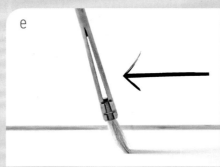

A brush, full of water or paint, should be swept back and forth with very little movement in the wrist; you should work almost completely from the shoulder (Figs. **d** and **e**).

CUTTING

The beauty of flat brushes is that they can also be used to create a completely different brush stroke.

Because of the chisel-shaped brush head, the motion of a flat brush or hake can be in line with the sharp edge. This thinner brushmark can be cut across to produce long narrow lines. Pictured is a 12mm (½in) flat brush. I wet the brush and then flattened the brush head by pulling the bristles between my fingers (Fig. **a**). The flat edge was then touched into the paint and cut from side to side, creating a fluid zigzag pattern. (Fig. **b**)

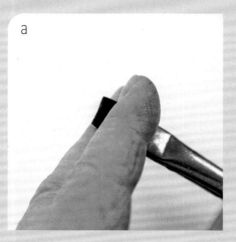

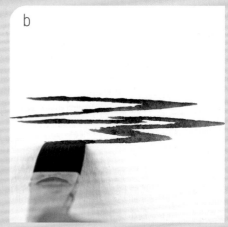

Other techniques

LIFTING OUT

Once watercolour paint has dried, it is possible to remove the paint and restore the white surface underneath. A firm brush head is best for this technique, hence why I use a 6mm (¼in) synthetic flat brush.

The brush is wetted first and then applied with a vigorous scrubbing motion (Fig. **1a**). This area can then be dabbed with some paper towel, which removes the paint (Fig. **1b**).

To produce white reflections in rippling water, the brush can be cut across (see opposite) and then dabbed (Fig. **2**).

It's also possible to tease out paint in a wet wash to create a soft, 'foam' effect (ideal for crashing waves). Gently touch the wet surface with a scrunched-up paper towel (Fig. **3**).

It is important to note that lifting out dried paint is less effective on both poor-quality paper and those made with pure cotton. In both cases the paper is more absorbent so the paint becomes harder to remove completely.

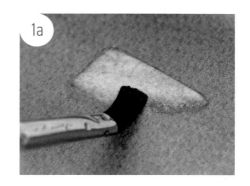
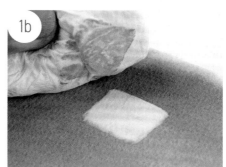
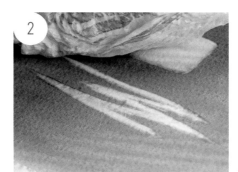
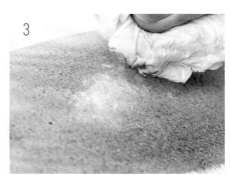

ADDING FLYING BIRDS

Birds can bring life and movement to a scene but they can also ruin a perfectly good painting if they are done badly. I use a size 2 rigger, a brush which has lovely sharp tip that holds plenty of paint.

I use a fluid dark paint and start at the tip of one wing, bringing the brush softly down. I paint a gentle curve, stop to paint a tiny blob for the body and continue the brush stroke off the paper with another gentle curve, creating the other wing. This method produces sharp wing tips. I strongly recommend practising a few birds on a scrap piece of the same type of paper before committing to the painting. This helps to ensure the paint consistency and state of the brush tip are perfect.

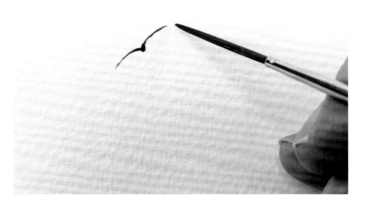

Watercolour paper

Watercolour paper is far from being a standard product. Each maker uses different blends of materials and specific manufacturing methods. It is important to note that the performance of the paint and what you can do with it varies enormously depending on how the paper is made. As a watercolour artist, it is important to have an understanding of different papers, what they allow you to do and how the paint responds on them. The best way to establish this is to try them out.

SIZE

Most papers are treated with a starchy glue-like substance to give them a stronger, less absorbent surface. This is known as 'size'. The process of sizing differs from one maker to another, and can also have a significant effect on the properties of the paper.

COTTON VS. WOOD PULP

Good-quality papers are inherently manufactured to a higher standard, and go through processes that help give them strength, retain their integrity and enhance the overall painting performance. Papers that are made from cotton are generally regarded to be of a higher quality but are also more costly, as you might expect.

Most inexpensive papers are made from wood pulp and contain no cotton. The variety of wood-pulp papers on the market is extensive. Some wood-pulp papers made for the budget market have very little size (see above) and can be weak structurally. It is not for me to name names and end up getting sued, so all I can do is recommend that you stay away from very cheap paper. Substandard paper will dramatically affect the performance of the paint and give really poor results regardless of the competency of the artist. It is important to note that there are some really good-quality wood-pulp papers available to buy and many of them are used by professionals, me included.

TEXTURE

Watercolour paper that is described as 'NOT' is sometimes known as 'cold pressed', and has a coarse bumpy surface. You might expect the word 'NOT' to be an acronym for some fancy description of the paper; it is actually much simpler than that. The word 'NOT' is just a traditional term and literally means 'not hot pressed' or, in other words, 'cold pressed'. A bit confusing but that is just the way it is!

Cold-pressed (NOT) paper has a medium texture. Most paper manufacturers produce a coarser surface where the lumps and bumps are higher. This surface is known as 'Rough'. It is possible to get 'Extra Rough' for those who like a highly textured finish and extreme granulation. The dry-brush technique works very effectively on a rough surface – for more detail on this, see pages 85, 86 and 87.

WEIGHT

The thickness of paper is expressed as a weight related to either its size or its breaking strain. Imperial measurements quoted in pounds (lbs) are related to the strength of the paper, whereas metric measurements relate to weight per surface area ('grams per square metre', or 'gsm'). This is a bit confusing, and for the purposes of this book especially it is not really important to fully understand. All that is relevant is that the weight of paper is usually quoted in both imperial and metric figures. The higher the number, the thicker it is.

For most watercolour painting, I would recommend NOT 300gsm (140lb). Anything thinner will buckle extensively and absorb very little water, which will result in a much faster drying time.

Tools and materials

In addition to the brushes and paper described earlier, here is a selection of materials and equipment that should be part of your watercolour kit and are used throughout this book.

PAINT

As mentioned before, I prefer to work with paint tubes as opposed to pans. The Cotman range by Winsor & Newton are good-quality watercolour paints for students. There are plenty of other good brands available too, but my advice is to avoid budget paints that are generally found in full sets for just a few pounds. They simply don't perform very well in my view. Most brands have a superior range called 'Artists' Watercolour' or 'Professional'. Without doubt they are better quality and have an intensity and permanence that outshines the student paints, and there is a much greater range of colours. However, they are up to four times the price and I'm not convinced that it is worth the extra – especially if you are a beginner and are using the paint for practising.

PALETTE OR MIXING TRAY

There are various palettes available, many with wells for holding loose washes. When painting skies in particular, it is important to have an expansive flat area so that the broad brushes have room to pick up the paint. I have always found wells to be a bit of a nuisance so I use a flat tray, as pictured. As with many things, it is just a case of personal preference.

WATER POTS

There is nothing technical to impart about these. Any receptacle with water in it will do. I like to use wide-rimmed vessels, such as cleaned-out yogurt pots or jars that have a big enough diameter to be able to get my wide hake brushes into. Most artists will set up with two water pots, one for washing the brushes and one for the availability of clean water.

CLOTH OR RAG

A cloth or rag to hand is essential to help keep control of the water in the brush.

PAINTING BOARD

Any flat, rectangular panel will do – MDF or plywood will do nicely – so long as it is big enough for the paper with a bit to spare. It will also need to be propped up so that it slopes towards you slightly at an angle of about 15 degrees. I never paint on a level surface because the water on the paper will tend to stand in puddles, or move off in random directions, making it impossible to control. On a gentle slope, the paper will tend to dry from the top down as the water travels by force of gravity. This also aids the prevention of unwanted watermarks. The exception to this rule is when the artist actually wants wet paint to remain in one place for longer so that colours can be dropped in to diffuse and blend. This is mostly a requirement when painting flowers in a really loose style.

PAPER TOWEL

Paper towels are ultra absorbent and are an important part of the kit. They can be used for the removal of wet paint from the paper or a brush, as required.

MASKING TAPE

I always recommend that you tape the paper to the board with masking tape all the way round the edge without any gaps. If you tape only the corners, for example, the untaped edges of the paper will curl up when subjected to water. The paint will then run into the central area of your work and ruin it.

You can also use masking tape directly onto dried watercolour paint to create really straight lines such as the horizon of the sea. The paper should be of a robust type to do this and the tape needs to be very sticky, otherwise the paint will creep underneath. Even a really tacky masking tape can normally be removed successfully by heating up with a hairdryer (take a look at step 17, page 45).

It's worth investing in good-quality tape as this will stay put. Low-tack or poor-quality tape will cause all sorts of problems because it lifts off with ease when it is subject to constant wetting and drying.

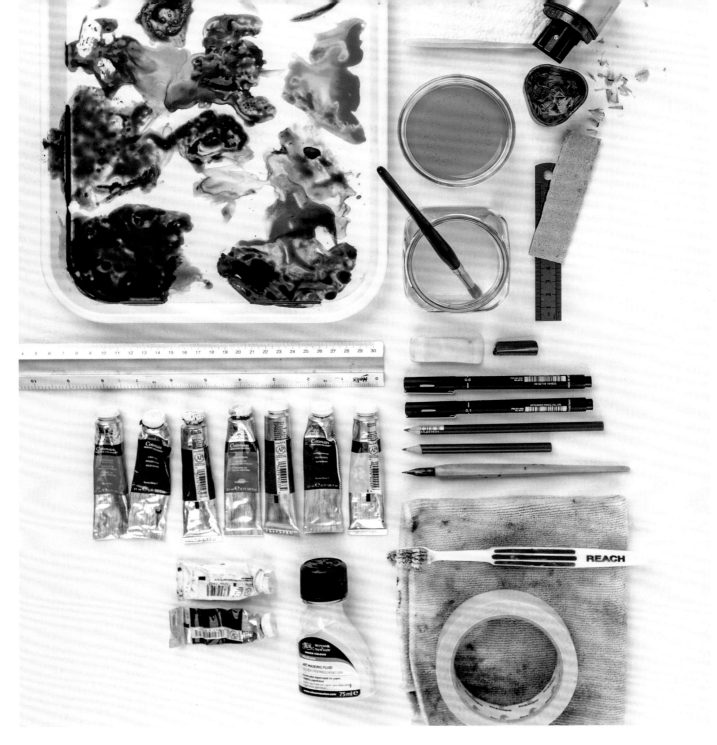

HAIRDRYER

A hairdryer enables you to get on with the next stage of the painting a bit sooner. Particularly when a sky has been created, the developing paint might reach a stage where no further movement is required. At this point, the paint can be fixed in place with a blast from a hairdryer. Be careful though: if a sky is still very wet, the powerful air from a hairdryer can displace the paint.

OTHER EQUIPMENT

I recommend a decent quality soft pencil such as a B or 2B. I see many people using really hard, cheap pencils, which tend to permanently mark the paper with grooves. Other requirements include a soft eraser, a small straight-edged ruler (see page 40) and a bevelled ruler (see page 51), medium-grade sandpaper (see page 40), masking fluid (see page 59), a dip pen and metal nib (see page 59), and a white medium such as white gouache (see page 75).

Working from photographs

The idea of painting outdoors is a lovely one but rarely do we get the opportunity. It is a challenge carting all the necessary gear around and setting up in an outdoor location. There is, of course, the issue of weather, and to some the embarrassment of being watched by anyone passing by! Therefore, most of us prefer to use photographs as a reference for paintings instead. When it comes to painting from photographs, I do have some important tips.

First, there is no need to recreate the scene exactly; if needed, alter certain areas to improve the overall composition. For example, the general scene is right for your painting, but the sky may be a little insipid. Photographs are usually taken as a snapshot of a particular scene and not necessarily because of the sky. Challenge yourself with this question. How many times have you painted a scene from a photograph and created an entirely different sky from the one in that photograph? I will often design a sky to suit my painting, as rarely do I find a sky in a photograph that is just right for the scene itself.

Second, don't be afraid to simplify a scene. Often photographs contain a considerable amount of detail, and as a result may be 'cluttered' with too many individual features. Much of this can be a little ambiguous too (by this, I mean there may be parts within the image where it is not quite possible to make out what is going on). Therefore, you may consider 'moving things around' in your final painting, or perhaps leaving things out completely, for the sake of compositional strength. Artistic licence can also be employed by adding things which aren't there at all!

Third, when using a photograph as a reference for a painting, it is easy to become fixated on the details within it. Constantly glancing at a photograph while attempting to re-create the detail will substantially slow down the whole process and could easily lead to a dry, streaky, overpainted result. Watercolours should be completed swiftly and decisively with plenty of water.

Finally, I would always recommend the preparation of a sketch. The artist can then make decisions about compositional exclusions, additions and placement at this early stage. In my experience, it is much safer working from a sketch than directly from a photograph. See pages 8 and 88 for more information on this.

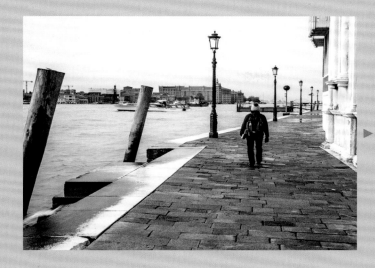

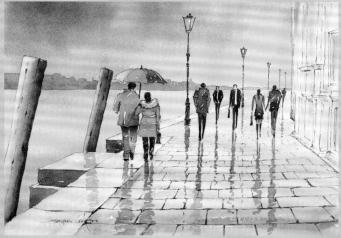

Wet Day in Venice
38 x 28cm (15 x 11in), Bockingford NOT 300gsm (140lb)

I adapted this photograph by focusing on the perspective and primary foreground features. I simplified the background details in the distant buildings, boats and water and populated the pavement with several figures. I also created reflections to make the scene wet. This is a classic 'line and wash' painting where most of the drawing was done first with a pen and the paint applied afterwards.

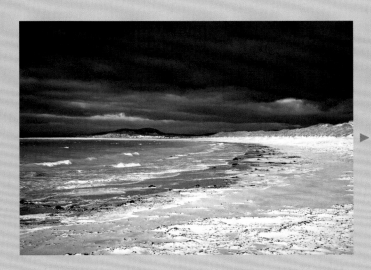

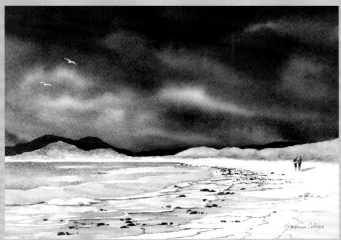

Stormy Hebrides
33 x 23cm (13 x 9in), Bockingford NOT 300gsm (140lb)

This amazing photograph, taken in the Hebrides in Scotland, UK, caught an unusual moment when the sun was shining brightly on the foreground beach, while the sky and background hills were extremely dark due to an approaching storm. In the painting I cropped some of the lower beach and left-hand side so that I could drop the horizon a little, allowing me to create a more dramatic sky. The beautiful turquoise sea and white sand, typical of this coast, offered an extreme contrast against the black sky. I also added a couple of figures walking on the sand, which allowed me to paint shadows to exaggerate the sunlight. I painted the birds with permanent white gouache using a rigger (see page 23 for more on how I paint birds).

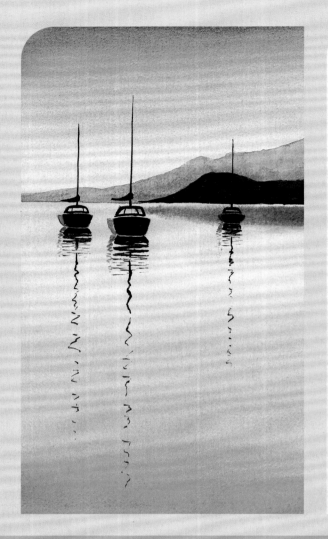

Water

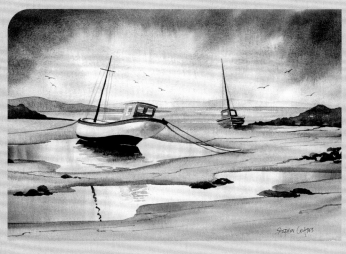

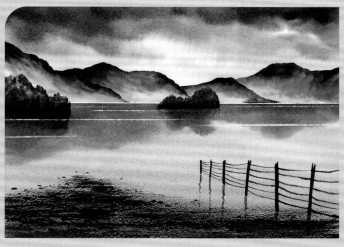

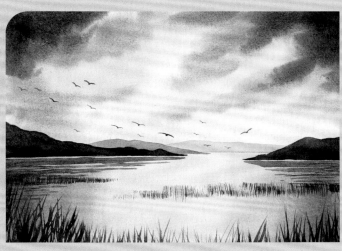

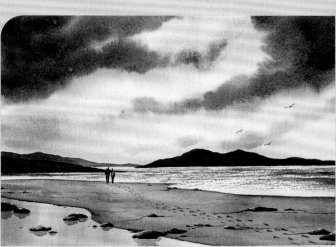

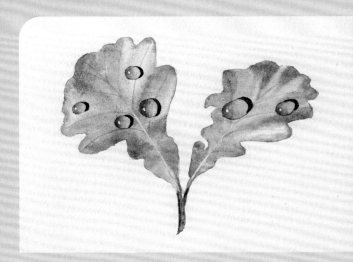

Lakes and calm water

Any inland body of water can be subject to the same weather conditions as the sea. However, waves on lakes, generally caused by wind, are less dynamic than sea waves as they don't have enough distance to travel for the energy to build up before it is dispersed on the shore. Therefore, a lake tends to be calmer and have more mirror-like reflections, the appearance of which will be governed by what is happening on the surface of the water. Refer to pages 10-12 where these conditions are explained in more detail.

Lakes, dams and reservoirs are all surrounded by landforms. These surrounding areas can be mountainous, lined with trees or populated with man-made structures. Whatever lies on the opposite side of a lake, you can be sure that there will be something present that will create a strong reflection. This also applies to anything within the lake itself, such as a boat or a jetty.

The two projects in this section feature two different surface conditions (explained on page 12). In the first, Reeds in the Shallows, the lake is calm but for a few ripples and undulations, resulting in shiny streaks of vertical light in the water from the clouds and broken ripples reflecting below the landforms. In the second, Misty Lake, there are some ripples but there is a persistent wind causing the surface of the water to shimmer, which results in blurred reflections.

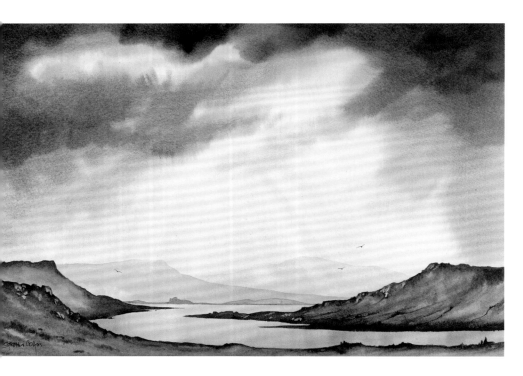

Cumbrian Light

55 x 35cm (22 x 14in),
Bockingford NOT 425gsm (200lb)

The plan with this painting was to create a huge dramatic sky with sunbeams. The lake is reflecting light from the sky with soft vertical streaks of colour which feature in the first of the two projects in this section.

SOFT VERTICAL STREAKS

The 'shine' in water, which can be seen in a photograph on page 12, combines all the colours in the sky, represented and reflected in soft vertical streaks of colour. This important feature forms the basis for the first project and appears in several others throughout the book.

To create these soft vertical streaks, the paper should be wet first. The colour is then drawn down swiftly, with the brush held so that the full width of the brush tip is in contact with the paper and also parallel to the horizon. Each brush stroke should be delicate, absolutely straight and pass all the way down with long single movements. To help achieve these brush strokes, it is worth adjusting your body position so that your arm can move down freely.

In this example, I have mixed ultramarine and light red to create a thick plum colour. There is also a small amount of cerulean blue on the palette, squeezed straight from the tube and not diluted with water.

1 Wet the paper first with an even film of water using a mini hake. Pick up some cerulean blue then, in the central area, paint a series of vertical streaks of colour, ensuring that each one is applied in a single continuous movement.

2 Without washing the brush, pick up a small quantity of the plum mix. Like the blue, apply the plum in single long strokes, working from the far left towards the centre. The plum colour should 'fade' as you move to the right.

3 Repeat the process in step 2, this time starting from the far right-hand side (**3a**) and moving towards the middle (**3b**). It is important to avoid picking up too much of the plum colour otherwise it may not be possible to leave a blue section in the centre of this wash. As you can see, the water on the paper softens the edges of these brush strokes. Without water, the streaks would have hard edges and look like striped pyjamas!

1

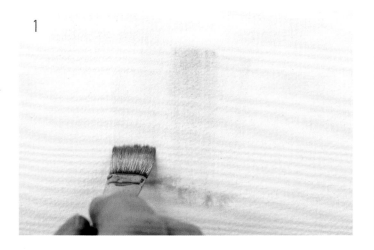

2

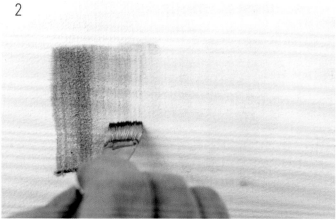

3a

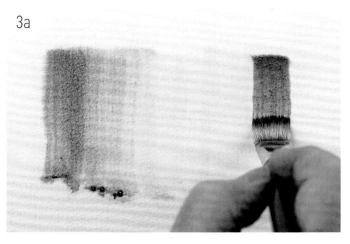

3b

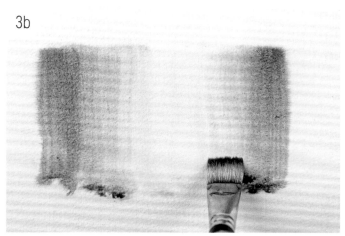

REEDS IN THE SHALLOWS

You will need

Brushes: medium hake, size 6 round, size 8 round, 12mm (½in) flat, medium Scimitar, size 2 rigger (optional)

Paints: ultramarine, cerulean blue, light red

Paper: 33 x 23cm (13 x 9in) of 300gsm (140lb) NOT, such as Bockingford

Extras: pencil, ruler, soft eraser, masking tape, hairdryer

1 MAKING A DRAWING: The horizon line is just below halfway down the page. It is important that this is not in the middle. The landform to the left should be drawn just below the horizon and stretch across beyond the halfway mark. The right-hand landform is a little nearer so the base should be slightly lower and stretch a third of the way across.

2 PREPARING THE PALETTE: Squeeze out a blob of ultramarine, light red and cerulean blue. Stir some water into the ultramarine until it is the consistency of olive oil, then stir in a bit of light red to achieve an indigo colour. The cerulean blue remains undiluted.

3 With a medium hake, wet the whole of the sky area to just below the horizon line. Pick up a little cerulean blue on the brush and flick it in patches across the sky area, leaving some white gaps to suggest white clouds.

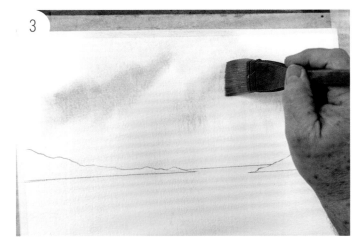

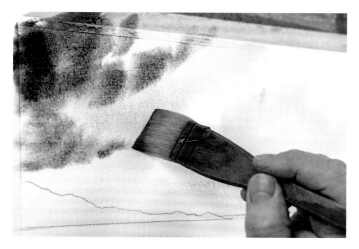

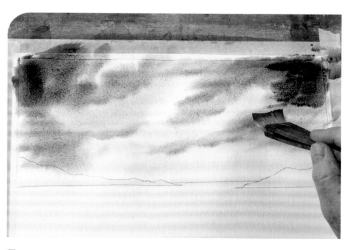

4 Without washing the brush, pick up some of the indigo mix and paddle the brush across the sky, forming the shape of the clouds and, again, leaving some white patches as well as areas of cerulean blue.

5 Once the pattern of the clouds has been created, finish off the sky by picking up more of the indigo mix and cutting it into the sky from the edges of the paper, to give the clouds more depth. Leave this to dry naturally for a while; this should allow the paint to soften and develop. It is important not to fiddle with the paint as it dries. Once it has settled, dry the painting with a hairdryer.

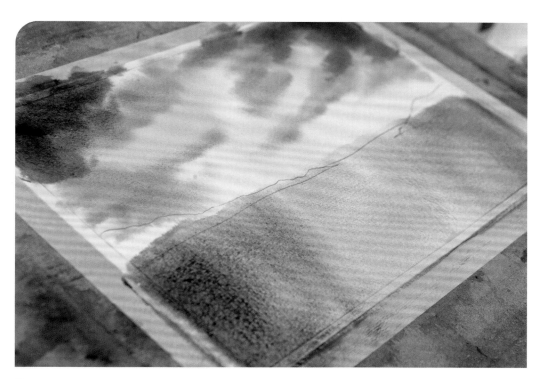

6 To create the shine in the water, follow the procedure on page 33 using a medium hake. Start by wetting the whole area of the water to just above the horizon. The brush strokes for the vertical streaks of paint will need to start from just above the horizon and pass all the way down. This should mirror the position of the colours above in the sky. The brush marks above the horizon will be covered with darker paint later, when the distant landforms are created.

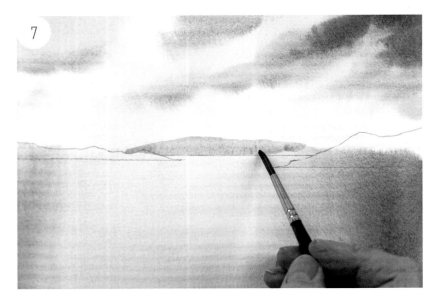

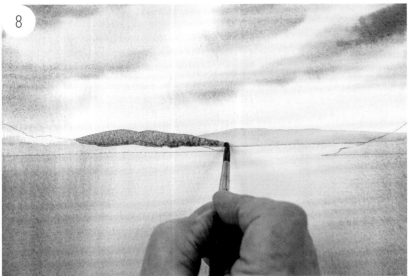

7 To create the most distant landform, take some of the thick indigo mix to one side on the palette then dilute it with water until it is the consistency of milk. Take the size 6 round brush, fill it with paint and gently sweep it across from left to right with as few strokes as possible and avoid going back to touch it again. Dry the painting with a hairdryer.

8 Add a little more of the thick indigo mix to the paint used in step 7 and repeat the process for the distant landform which is a little closer. Dry the painting with a hairdryer.

9 For the remaining two landforms, switch to the size 8 round brush and pick up the strong indigo mix. Paint them in using the same technique, starting at the wider outside ends and tapering off at the water's edge. Dry the painting with a hairdryer.

10

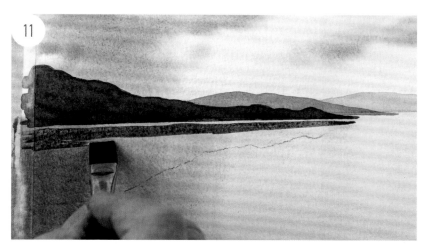

11

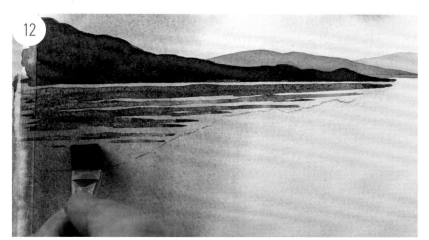

12

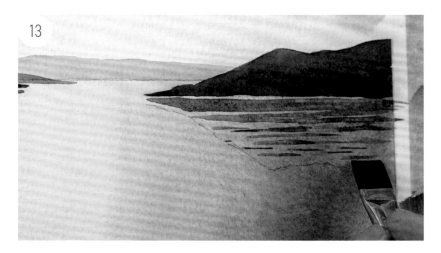

13

10 It is possible to draw then erase pencil markings on paper with dried watercolour paint. The shapes of the reflections of the two nearest landforms need to be inverted and lengthened, so drawing on some guidelines can be helpful. The depth of the reflections in the water should be double the actual height of the landforms (an explanation on this given in the 'How reflections behave' chapter on pages 10 and 11). To create the rippling reflections of the landforms, start by wetting a 12mm (½in) flat brush then sharpen the bladed edge of the brush by pulling the bristles between your fingers.

11 Add a little water to the indigo mix to dilute it using the size 8 round brush, then dip the sharpened edge of the 12mm (½in) flat brush into this mix. Leaving a narrow gap immediately below the landforms, 'cut' the brush across the paper from side to side to create horizontal lines. Start off with a wider band at the top, below the left-hand landform.

12 Now gradually produce narrower lines, increasing the gap between them and breaking them up as you work towards the bottom of the reflection, as shown.

13 Repeat this for the reflection of the right-hand landform. Dry the painting with a hairdryer then erase all the pencil lines.

PAINTING REEDS

Use a hake to create the impression of distant reeds. This requires a little practice so I recommend you try this on a separate piece of paper first. The hake should be wet and then squeezed out a little to remove some water.

Press the brush down on a dry area of the palette to bend and splay out the hairs (Fig. **1a**). Dip the splayed hairs in the paint, hold the brush horizontally and gently flick downwards, as shown, to create a series of split brush marks representing a bed of reeds (Fig. **1b**).

For larger, foreground reeds, I recommend a sword/dagger brush or the medium 'Stephen Coates' Scimitar brush (described on page 19). The brush head should be full of paint and the weight of the water should make the brush tip a bit wobbly. As you work one stroke, apply a little pressure and gently twist the brush to produce natural, broader reed shapes (Fig. **2a**). You can also create dozens of narrow fronds by using just the tip of the brush and flicking upwards (Fig. **2b**). Pictured here is a combination of two green mixes; in both cases the darker green was dropped into the light green shapes while they were still wet to blend.

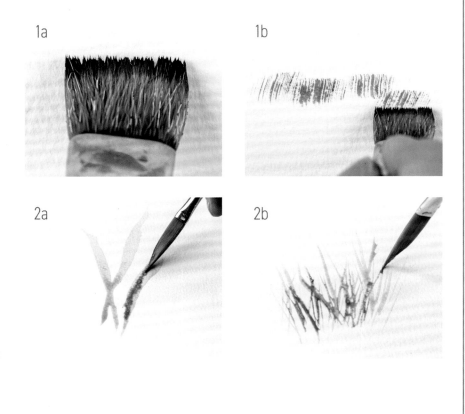

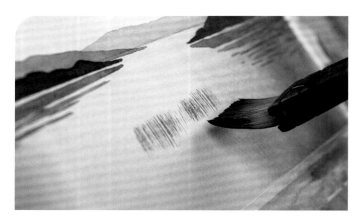

14 Using the indigo mix, add some distant reed beds with the medium hake, following the guidelines above.

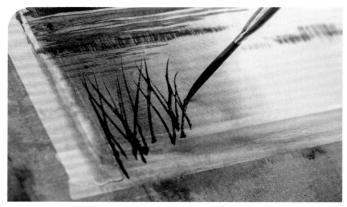

15 With the medium scimitar brush full of the indigo mix, create some foreground reeds, following the guidelines above.

▼ The end result. I finished off the scene by adding a number of migrating birds. This is obviously optional and you may decide not to include any at all. Guidelines for painting birds can be found on page 23.

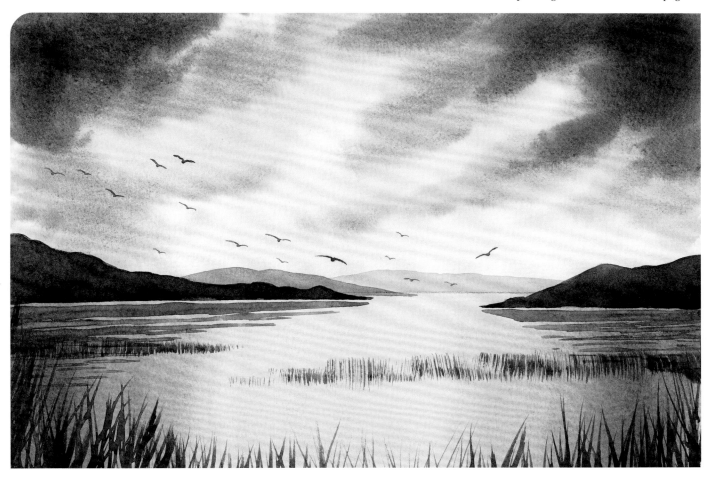

BLURRED REFLECTIONS: WET-INTO-WET

As you'll have read on pages 10–12, the wind can affect the surface of the water, and the various ways in which the wind blows result in different types of reflections (explained on pages 12 and 13). The following project features a lake with a steady breeze shimmering across the water, which produces blurred reflections.

In the example here, the sky was painted with a graded wash of cerulean blue. For the mountains I blended burnt sienna and burnt umber. The water was an inverted graded wash of cerulean blue, to mirror the sky. While this wash was still wet, I gently stroked in the inverted shapes of the mountains using the same colours as before. I then left this to settle naturally; this created blurred reflections.

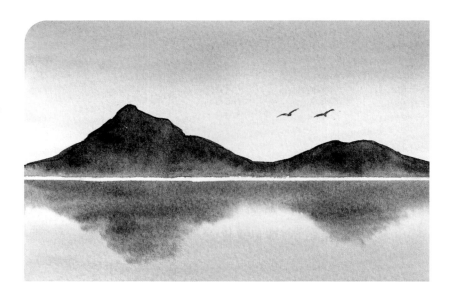

SANDPAPER LINES

Ripples extended across the surface of the water often catch the light and appear as white strips. They can easily be created by dragging some folded sandpaper across the paper, gently scouring the surface.

To do this, fold a piece of medium-grade sandpaper around the edge of a small, 10cm (4in) metal ruler – see Figs. **a** and **b**. An old credit card would also be fine. Place a 30cm (12in) metal ruler across the painted area, hold it firmly in place then drag the folded edge of the sandpaper across the surface of the paper (Fig. **c**). You can see the sandpaper scours away the paint on the elevated bumps in the paper, leaving a broken white line. I suggest you practise this before committing to a painting.

a

b

c

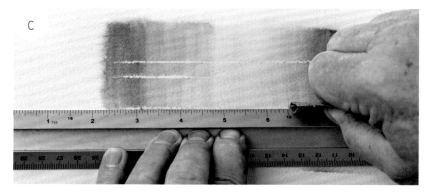

MISTY LAKE

This project is based on the photograph, right, of Derwentwater in the Lake District, UK. The reflections in the lake are blurred, indicating a gentle breeze blowing across the surface. Emulating this in watercolour involves a wet-into-wet technique (explained opposite), which involves painting the mountains' reflections into the water area while the paint is still wet. You can also observe some narrow strips of light in the water, caused by isolated gusts of wind or advancing ripples. These are re-created in the painting using the simple sandpaper technique, detailed opposite.

In addition to the mountains, you will need to create blurred reflections of the foreground islands. It would be extremely challenging to paint all the reflections in one go, so you will need to apply a 'glaze' over the reflections of the mountains, once the paint has dried, to add the reflections of the islands. I have chosen cotton paper for this project, as it will hold the paint more securely when glazing.

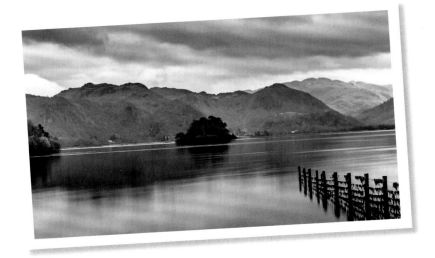

You will need

Brushes: large hake, size 2 round, size 8 round, size 10 round, size 2 rigger

Paints: ultramarine, burnt sienna, raw sienna

Paper: 38 x 28cm (15 x 11in) 100 per cent cotton 300gsm (140lb), such as Saunders Waterford

Extras: pencil, hairdryer, masking tape, 30cm (12in) metal ruler, miniature ruler (or old credit card), medium-grade sandpaper

1 MAKING A DRAWING: Draw a horizon line just above halfway. Draw in the distant mountain range and the foreground islands. (The fence in the foreground is drawn later.)

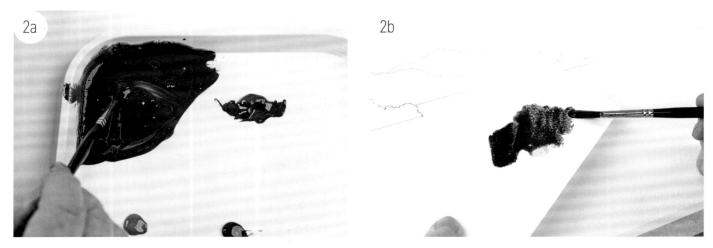

2 PREPARING THE PALETTE: Squeeze out substantial blobs of ultramarine and burnt sienna. You will also need separate small blobs of ultramarine and raw sienna; these will be used later, to make a green mix. Using the size 8 round brush, add some water to the ultramarine and stir all of it into a puddle the consistency of olive oil. Then stir in the burnt sienna (**2a**) until you achieve a dark warm mushroom colour. This thick mix will look very dark, so brush a sample on a scrap of watercolour paper, dilute it by adding some water and pull it away. This will reveal the true colour of the mix (**2b**).

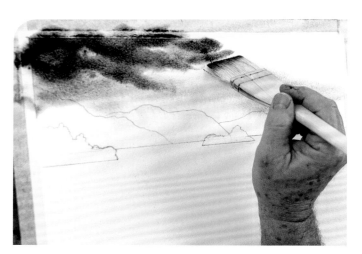

3 Wet the whole sky area, including the mountains, with a large hake. Pick up just a small amount of the mushroom mix and gently paddle in some light colour clouds, just above the mountains.

4 Pick up more of the mushroom mix and paddle this in from the top of the paper to create stronger clouds higher up in the sky, leaving some light sections above the mountain tops. Let the paint settle for a few minutes, and watch it develop. Once it has settled, dry off with a hairdryer.

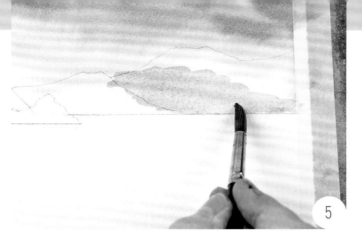

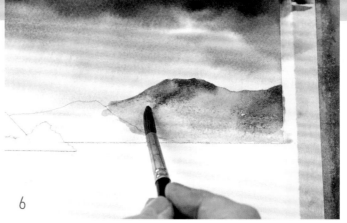

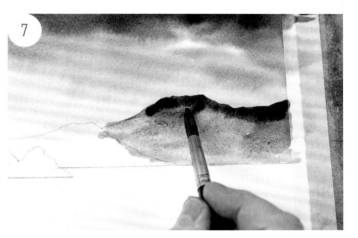

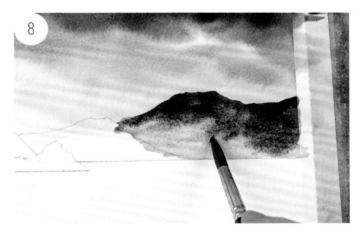

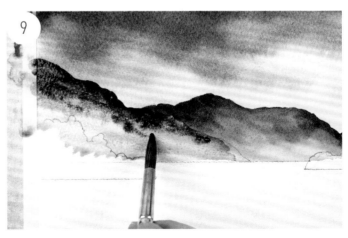

5 Now for the mountains. Each one should be painted independently then dried with a hairdryer. Start with the one on the right to ensure the correct overlap can be achieved. I would recommend a size 10 round brush for this. You will need to take a little of the strong mushroom mix onto a separate part of the palette and then add water to it to weaken it. Add some water to the burnt sienna until you have the consistency of double cream/ heavy cream. Fill the brush with the weakened mushroom mix and brush this across the whole area of the mountain.

6 Immediately pick up some of the loosened burnt sienna. Gently draw this down into the mushroom mix from the top downwards, ensuring that the burnt sienna stays clear of the lower area.

7 While the mountain is still wet, pick up some of the strong mushroom mix and drop this in along the top ridge, forming a rugged hard edge.

8 Gently ease the paint down into the burnt sienna. Don't overwork this; let the colours suffuse and soften. This should leave you with a soft misty light area at the base of the mountain. Dry with a hairdryer.

9 Repeat this process with the remaining mountains, working from right to left and remembering to dry with a hairdryer between each one.

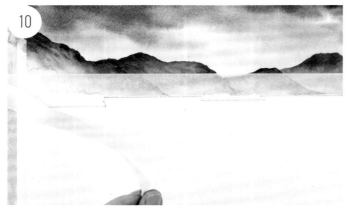

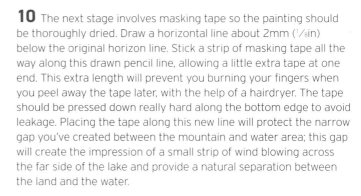

10 The next stage involves masking tape so the painting should be thoroughly dried. Draw a horizontal line about 2mm (¹⁄₁₆in) below the original horizon line. Stick a strip of masking tape all the way along this drawn pencil line, allowing a little extra tape at one end. This extra length will prevent you burning your fingers when you peel away the tape later, with the help of a hairdryer. The tape should be pressed down really hard along the bottom edge to avoid leakage. Placing the tape along this new line will protect the narrow gap you've created between the mountain and water area; this gap will create the impression of a small strip of wind blowing across the far side of the lake and provide a natural separation between the land and the water.

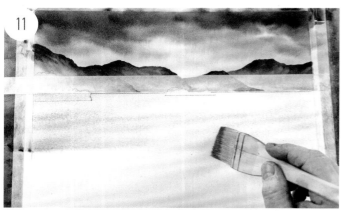

11 Wet the whole area of the water with the large hake by sweeping clean water all the way across from side to side. Pick up a little of the strong mushroom mix and apply it to the water area in the same way – sweeping and working from side to side. Concentrate on the upper area of the water, below the masking tape, as shown.

12 Immediately pick up a substantial amount of the strong mushroom mix and apply it across the lower area of the water. Work quickly, smooth it out and then leave it to blend into the lighter colour above.

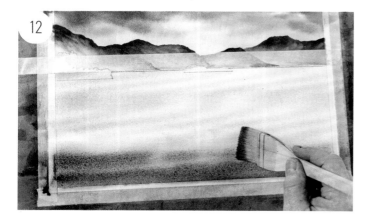

13 While the water area is still wet, with a clean, damp size 10 round brush pick up plenty of the loosened burnt sienna and sweep this quickly below the mountain area on the right, creating the inverted shape of the mountains above.

14 Repeat for the other mountain reflections. You should hold the brush at a low angle and 'scribble' quickly to disperse the paint until the whole area of reflections has been covered.

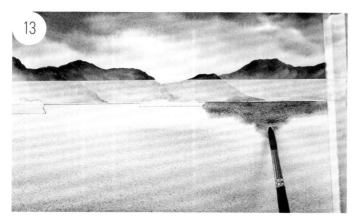

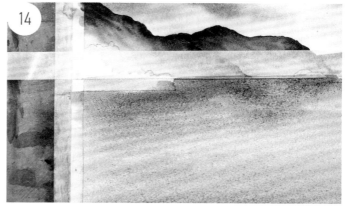

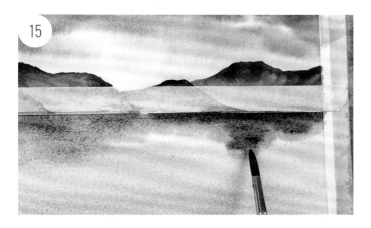

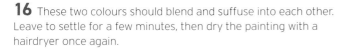

15 Immediately pick up some of the strong mushroom mix and 'scribble' it into the burnt sienna reflections.

16 These two colours should blend and suffuse into each other. Leave to settle for a few minutes, then dry the painting with a hairdryer once again.

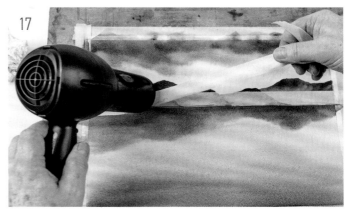

17 When the painting is completely dry, you can remove the masking tape. Get the tape hot by heating it with a hairdryer (this helps melt the glue on the tape, easing the removal process) then slowly start to peel away the tape, shadowing it with the hairdryer. The tape should come away completely and leave a narrow white strip all the way across.

18 The next step involves putting a glaze of water onto the area of the lake so that the reflections of the islands can be created. The glaze needs to be applied before the islands are painted, which may seem a rather strange order of play as the reflections will exist before the islands themselves. First prepare the palette for the islands. Add a little water to a blob of raw sienna until it is the consistency of double cream/heavy cream, then stir in a small amount of ultramarine to create a deep khaki green colour. You will also need to make sure you have plenty of the strong mushroom mix (see step 2 on page 42, if you need to make more).

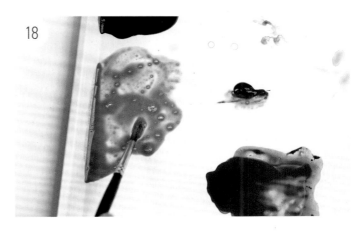

19 Now for the glaze. Wet the whole area of the lake for a second time, using the large hake and lots of clean water. Gently ease the brush across, without adding too much pressure but making sure the water is evenly distributed. Work overlapping horizontal bands delicately to achieve this. A little of the paint from steps 12-16 may loosen, but don't worry about this.

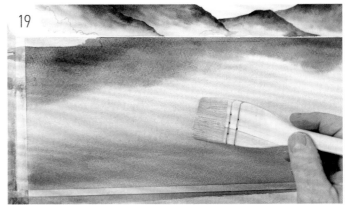

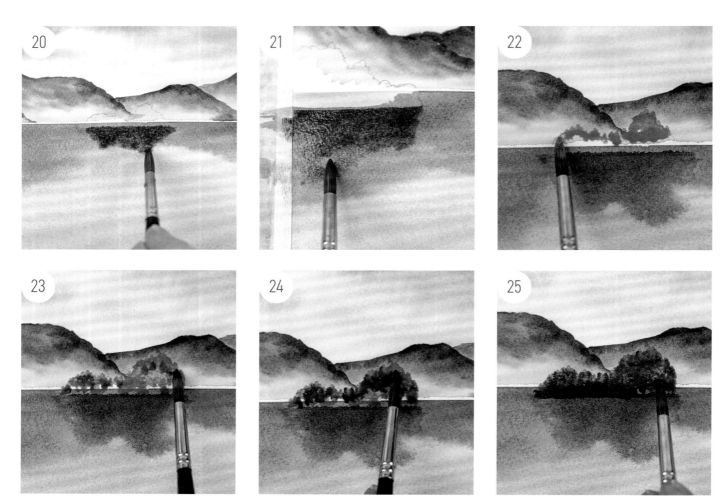

20 Once the whole area is covered in water, take the size 10 round brush, pick up the strong mushroom mix and touch the paint in to create the reflections of the central islands. Don't worry if the paint spreads a little. If the colour looks a little too pale when it spreads, pick up a little more of the mushroom mix and drop it directly under the line of the island.

21 Move quickly to the island on the left and repeat the process. Both of these reflections need to be in place before the water dries. Once settled, dry the painting with a hairdryer.

22 To represent the trees on the islands, hold a size 8 round brush vertically and at a low angle then dab it repeatedly with the khaki mix to create pointed tree tops. You can adjust the shape of the island at this point to match the inverted reflection if it didn't quite go to plan.

23 While the khaki paint is still wet, touch in a little burnt sienna here and there to blend in.

24 Then, pick up the strong mushroom mix and 'tap' this into the trees, increasing the strength of the mix towards the bottom of the islands where there are more shadows.

25 Finish off the island at the base with a flat edge, using the same strong mushroom mix.

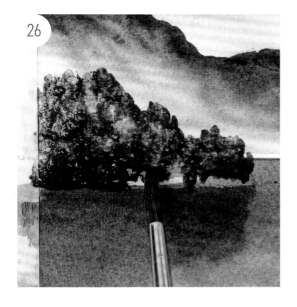

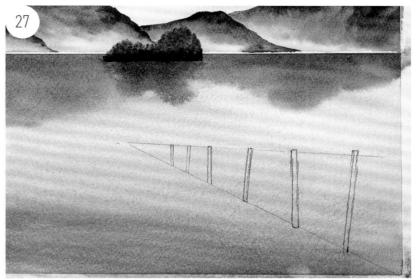

26 Repeat this method for the island on the left.

27 Now you can use a pencil to draw in the fence posts. A vanishing point (VP) is required so place a dot in the lake a little way below the middle island. Now use your larger ruler to draw two lines that converge at the VP – one intersects the lower right-hand corner and the other about halfway between the horizon and the same lower corner. Then, draw the fence posts within these lines, making them narrower and closer together as they get further away. Vary the angle of the posts to add character and then erase the VP and guide lines.

28 The gravelly foreground beach requires a dry-brush technique (fully explained on pages 21, 85, 86 and 87). Clean the size 10 round brush and scrape it on the rim of the water container to remove most of the water. Hold the brush at a low angle, dip it into some burnt sienna and pull the brush across the surface of the paper. The paint should catch the texture but not flow out of the brush, producing a broken effect.

29 Once the burnt sienna has dried, repeat this technique with some of the strong mushroom mix, layering it over the top of the burnt sienna to give the beach some variety and depth.

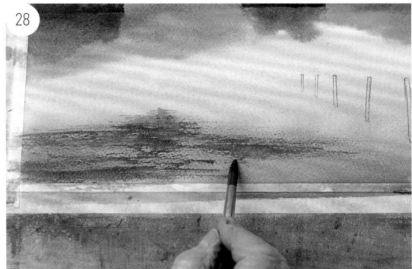

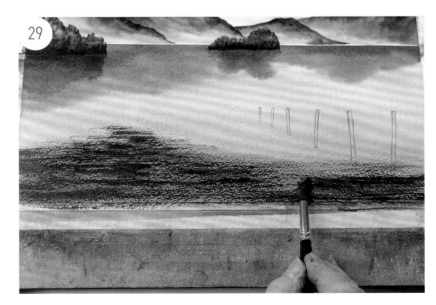

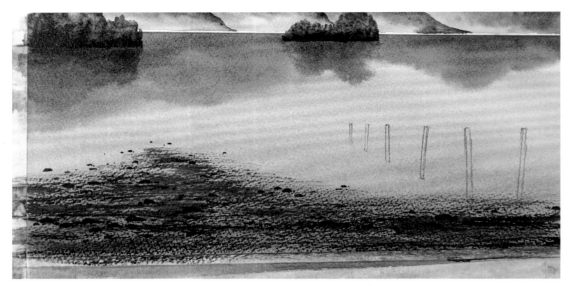

30 Using a size 2 round brush and the strong mushroom mix, populate the beach with little stones and pebbles, placing some larger ones in the near foreground. Some of these can be in the water too, just beyond the beach.

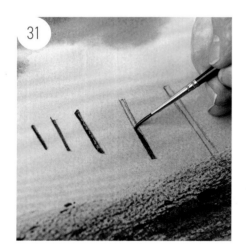 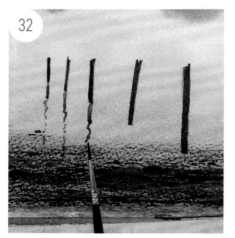 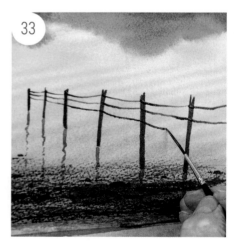

31 Using the size 2 round brush and strong mushroom mix, paint in the fence posts.

32 Then paint a reflection of each post using a slightly weaker version of the mushroom mix: leave a tiny gap, start with a straight line and then break into a 'wobbling' stroke and continue all the way through the paint on the beach. Take into account the angle of the posts: if they lean, the reflections should lean the same way.

33 With the size 2 rigger and the strong mushroom mix, paint drooping lines of wire in between each fence post. Pay attention to perspective – the wires should get further apart towards the foreground.

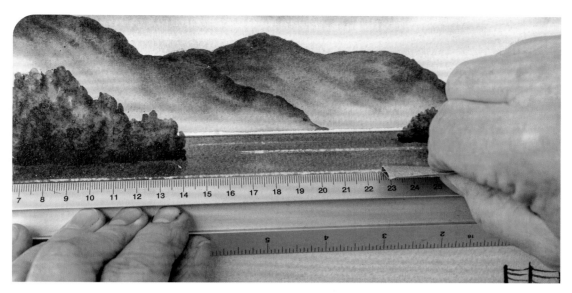

34 The long ripples in the water are created using the sandpaper technique (see page 40). As you can see in the finished painting below, the lines should be a little closer together higher up and vary in length.

 The finished painting.

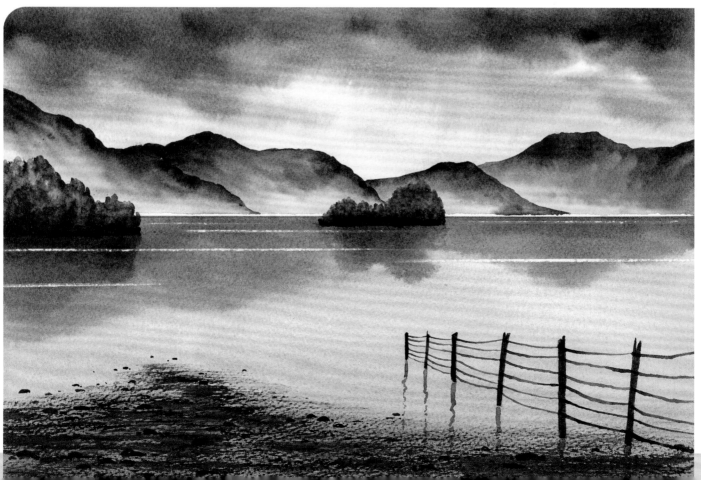

WATER TWO
Boats and water

There is something particularly evocative about a scene that includes boats. It might be fishing boats hauled up on a beach, or maybe they are just bobbing around in a harbour. Perhaps it's a lake at sunset, with the reflections of masts spiralling down into the gently rippling water. Paintings of scenes with boats seem to appeal to most people and, are of great interest to the artist. A boat will almost certainly reflect in water (unless, of course, it is the aforementioned beached boat on dry land!). In my view, it is the very presence and variety of these reflections that makes the subject so special, and has inspired me to study it for many years.

Boats are incredibly difficult things to draw, let alone paint. My advice is to keep it as simple as possible. A boat in water will most likely have a reflection so, the more complicated the boat, the more challenging the reflection will be. Another issue is when boats are white. This poses a particular challenge to the watercolour artist, because the white space required for both the boat and the reflection is a situation for serious thinking. More on that later though (see page 56). To begin, I'd like to share with you some techniques and projects you can try to help you create boat scenes in which the water is alive and shining!

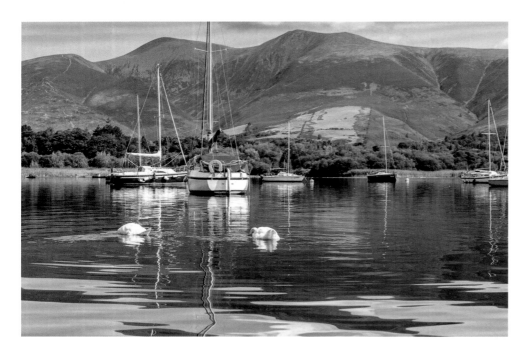

◀ In this photograph, the white boats stand out against the darker colours in both the water and the background. The white reflections of the boats and masts are clearly visible in the darker water. With watercolour, it is not really possible to cover darker areas with white paint in order to re-create these white reflections. Understanding this poses quite a challenge to the watercolour artist so, on pages 56–59, I have suggested three alternatives to help deal with this issue.

PAINTING STRAIGHT LINES

One of the most common challenges of painting boats is creating a straight mast. You can try painting them freehand, of course, and the odd wobble may not be an issue – especially if the painting has a more impressionistic style. However, most people get a little frustrated if an attempt at a straight mast results in a bit of a mess.

As you may expect, the best way to achieve straight lines is to use a ruler. You will need one with a steep bevelled edge (Fig. **a**). Flip the ruler so one bevelled edge is flat down on the paper (Fig. **b**). Rest the ferrule of the brush against the raised edge of the ruler then gently pull the brush towards you, keeping the ferrule in contact with the ruler at all times (Fig. **c**). A little practice is recommended.

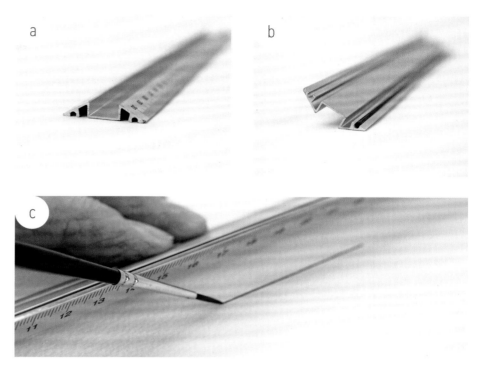

a

b

c

Waiting for the Tide

35 x 55cm (14 x 22in), Bockingford NOT 425gsm (200lbs)

I came across this boat in a photograph while searching for images online. The rest of the scene is a figment of my imagination. I used masking fluid to cover the shape of the boat before painting the sea and beach, thus retaining the white space (see page 59 for more on this technique). The reflection of the sun and sky in the pool feature the vertical streaks of colour described on page 33.

SERENE MOORINGS

This scene of three yachts on a lake is set in the evening, and features two types of reflections – the blurred reflection of the far-off landform, suggesting a distant gentle breeze, and rippled reflections in the calmer foreground water.

You will need

Brushes: mini hake, size 2 round, size 8 round

Paints: raw sienna, burnt umber, ultramarine

Paper: 23 x 33cm (9 x 13in) of 300gsm (140lb) NOT, such as Bockingford

Extras: masking tape, soft eraser, pencil, bevelled ruler, hairdryer

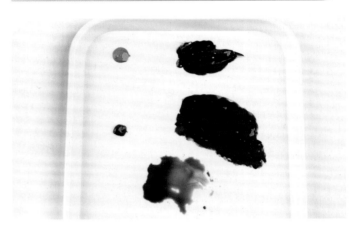

1 MAKING A DRAWING: Draw a horizon line about a third of the way down the paper. Along this line, sketch a near landform on the right-hand side. Decide on the position and size of your three boats then carefully draw these just below the horizon line. Note the slight difference in position in my own drawing, and how you can also just see the left-hand side of all three boats.

2 PREPARING THE PALETTE: Squeeze out a blob of raw sienna and ultramarine onto the palette and two blobs of burnt umber. Leave the blob of raw sienna and one of the blobs of burnt umber undiluted. Add a little water to the second blob of burnt umber and then stir in a little ultramarine to create a strong sepia shade. Put some of this to one side and add more water to create a much thinner version of it. These two shades of sepia are used to create the two landforms.

3 Use the mini hake to wet the area of the sky with an even film of water. Pick up some raw sienna and sweep it across the sky area from side to side, working up from the horizon.

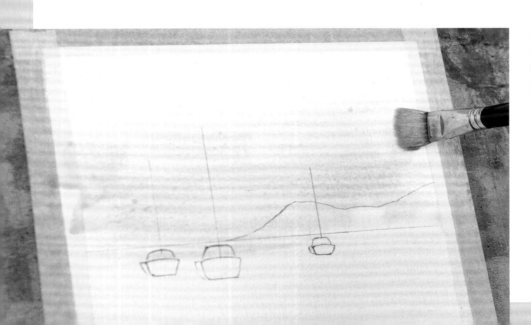

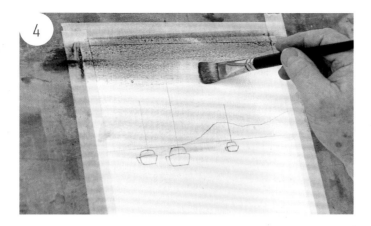

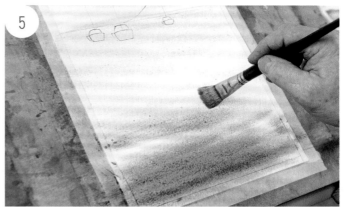

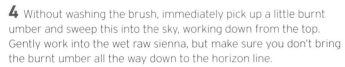

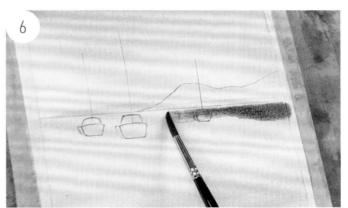

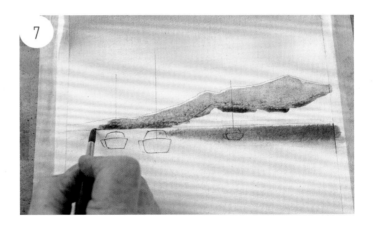

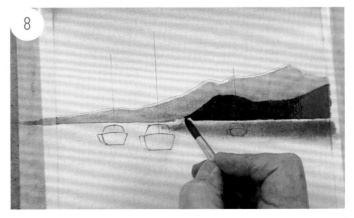

4 Without washing the brush, immediately pick up a little burnt umber and sweep this into the sky, working down from the top. Gently work into the wet raw sienna, but make sure you don't bring the burnt umber all the way down to the horizon line.

5 Repeat this process for the water but the other way up: wet the water area first, sweep in the raw sienna from the horizon line downwards, then gently sweep in the burnt umber from the bottom of the paper upwards.

6 While the water area is still damp, gently sweep in a reflection of the near landform with the size 8 round brush and strong sepia mix, working from right to left and leaving a narrow gap between the bottom of the land and the top of the reflection. Let the colour taper off at the left-hand end of the reflection. Leave the paint to settle and blur for a few moments before drying the painting with a hairdryer.

7 Behind the foreground landform, and along the empty left-hand side of the horizon line, mark in a distant landform. This is a guide line and will be erased after applying the paint. Fill a size 8 round brush with the loose sepia then work the paint gently from the right-hand side. Keep filling the brush as you progress from right to left, in order to avoid any dry patches. The paint should be applied without touching the pencil guide line. Dry with a hairdryer.

8 Repeat this process for the nearer landform, this time with the thicker version of the sepia mix. Dry it all off and then erase the pencil line for the distant landform.

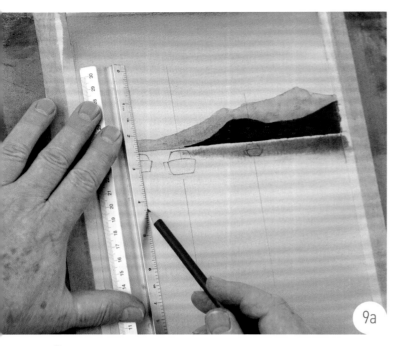

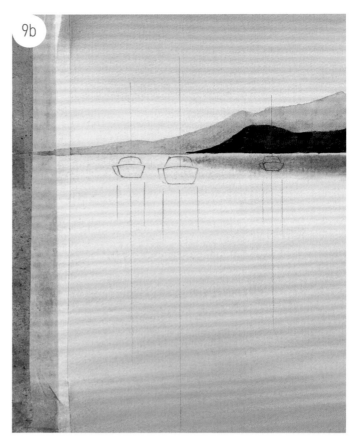

9 In order to assist with painting the reflections of the boats, temporary guidelines need to be drawn onto the painting. Hold the ruler vertically in line with each of the masts and draw an extended line down into the water (**9a**). Also do this with each of the extreme left and right edges of each boat although these don't need to be as long (**9b**).

10 To paint the boats you will need a much darker mix. To achieve this, stir in a little more ultramarine to the strong sepia mix to create a dark chocolate colour. Use a size 2 round brush to paint each boat silhouette, leaving the left-hand sides free of paint. Dry the boats with a hairdryer. Take some of the dark chocolate mix to one side of your palette, add water it until you have a loose consistency, then fill in the narrow left hand side of the boats

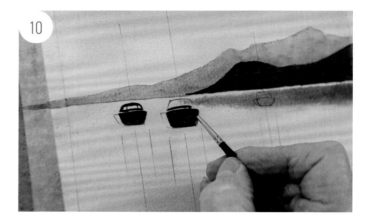

11 With the help of the bevelled ruler, paint the masts (see the technique on page 51). All three should vary in length.

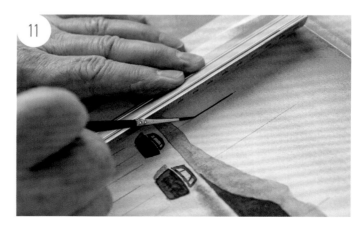

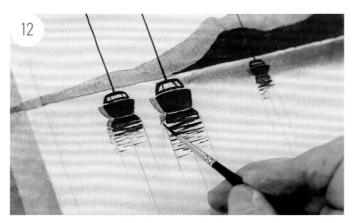

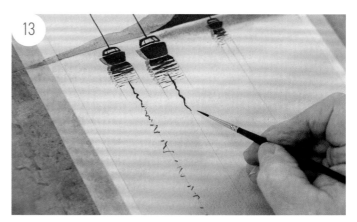

12 The reflection of each boat hull should mirror the shape of the actual boat, starting off solid and then gradually breaking into a series of lines further down. Ensure you paint within the guidelines throughout this stage. With this in mind, first paint the reflections for the darker part of the boat with the strong chocolate mix, using the size 2 round brush. Dry these with a hairdryer then paint the reflections for the paler, left-hand sides of the boat with the loose chocolate mix.

13 Finish off by painting the reflections of the masts, following the pencil guide lines drawn earlier, using the strong chocolate mix and the size 2 round brush. They should start off being quite straight, immediately below the boat hull, then break and wobble towards the bottom of the painting and, in fact, extend much farther than the actual length of the masts – roughly double the length. Completely dry off the painting and then erase all the pencil marks.

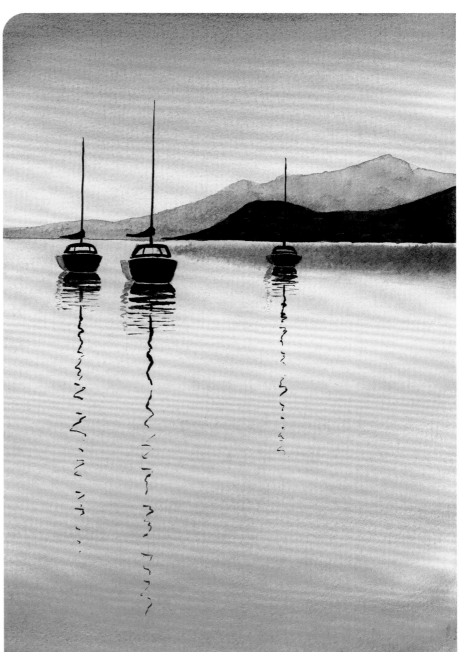

▶ The finished painting.

THE CHALLENGE OF PAINTING WHITE REFLECTIONS

Reflections of white boats always look beautiful as they stretch, shimmer and oscillate in the water. However, rarely will a watercolour artist create them with white paint. Paler watercolour pigments do not have the opacity to cover darker paint. Furthermore, trying to paint white paint over a layer of darker paint will result in a muddy colour, as the water in the white paint will re-wet the darker layer underneath, causing them to blend together.

Therefore, creating white reflections in watercolour poses quite a challenge to the watercolour artist, so it's a case of looking for some alternative methods. I would like to show you three ways to create white reflections, and all involve exposing the original white paper to create a white colour.

In the following examples, I've drawn a horizon line roughly a third of the way down, leaving plenty of room for some elongated reflections, and the same front-facing angle of a simple boat. I've also drawn in some guidelines, as seen in step 9 on pages 54. If you'd like to have a go at these examples, in addition to watercolour paper, a pencil and ruler, you'll also need ultramarine, cerulean blue and an indigo mix (created with ultramarine and a little light red); sizes 2, 6 and 10 round brushes; a 6mm (¼in) flat brush; paper towel; masking fluid; and either an old brush or nib to apply the masking fluid.

○○○ TECHNIQUE

LIFTING OUT

With this method, the background wash is applied across the subject and then dried. The paint that covers the required white areas is scrubbed with a wet brush and instantly removed with paper towel. This approach relies on the properties of the paper: cheap watercolour paper or paper made from cotton tend to be more absorbent; consequently, the paint may be more difficult to remove. It is also worth noting that a few alternative colours contain pigments which permanently stain the paper and may not lift out successfully.

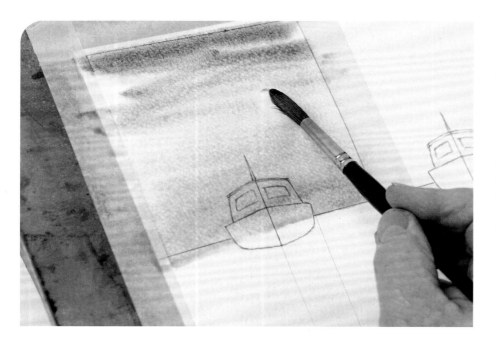

1 Wet the whole area of the sky by sweeping several brushloads of clean water evenly across the paper with a size 10 round brush, allowing the water to cross the horizon line. Pick up some cerulean blue and sweep this in from side to side, starting just below the horizon and working slowly upwards. Immediately pick up some ultramarine and work this in from the top, allowing it to blend with the cerulean blue. Any excess paint below the horizon line can easily be removed by giving the brush a squeeze with some paper towel and gently removing it. Dry this thoroughly with a hairdryer.

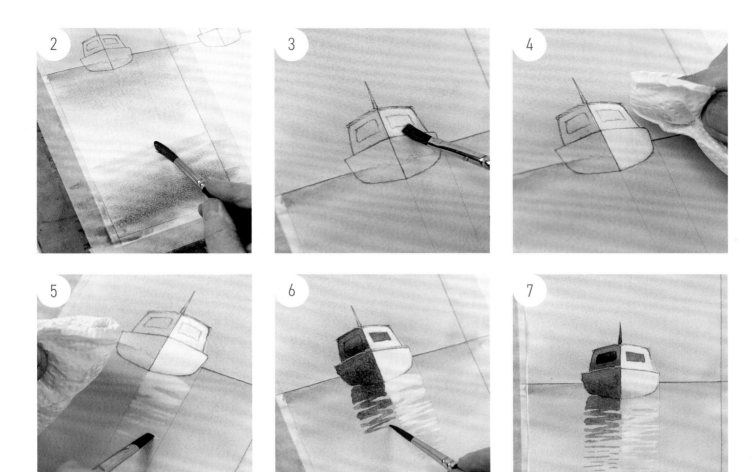

2 For the water, repeat step 1 but this time work the cerulean blue from the horizon line downwards then the ultramarine from the bottom of the paper upwards. Again, sweep the brush from side to side to keep the strokes as horizontal as possible. Don't worry too much if there are a few horizontal brush marks; they will look like ripples in the water. Dry the painting with a hairdryer.

3 To create the white side of the boat, fill a 6mm (¼in) flat brush with water and gently scrub at the paint on the whole of the right-hand side of the boat.

4 Dab the paint away with some paper towel. If it doesn't all come away the first time, keep repeating the process.

5 To create the white reflections, hold the brush so the sharp edge is horizontal then gently scrub away some lines. These should be as wide as the boat, directly under the hull, then gradually diminish in intensity as you work downwards. Increase the distance between each stroke and zigzag them slightly. Then, as before, dab off the paint with a paper towel. Note the overall length of the reflection is roughly double that of the boat itself.

6 Using the size 6 round brush and indigo mix, paint the left-hand side of the boat, leaving a narrow gap along the top edge of the boat hull. With the same mix and brush, paint the reflections for the left-hand side of the boat, following a similar pattern to the right-hand side.

7 To finish off, use the size 2 round brush to fill the white side of the hull with clean water then touch in a little of the indigo mix along the base of the boat to suggest its curvature. This can be repeated in the reflection directly below the hull. Paint the windows with a loose indigo mix. Finally, paint the left-hand window with a strong indigo mix.

NEGATIVE PAINTING

This method involves leaving spaces while painting the darker colours, allowing the white paper to show through and do the job of creating the white colour in the white and pale areas. This can be incredibly effective and often results in a painting that looks a little impressionistic. However, it is without doubt the most difficult to execute. There are two main challenges for us to overcome. Firstly, creating shaped white spaces while painting the background with a darker paint is not easy and can be complicated. Secondly, running watercolour paint around a negative space takes much longer to paint, which means you're likely to end up with streaks and watermarks in the final painting – as seen in my finished study below.

1 Wet the paper as on page 56, but this time avoid wetting the body of the boat. Wash in the cerulean blue from the horizon line upwards, again trying to avoid the boat. (If a little paint gets into the left-hand side, as mine did, it doesn't matter; this will be covered by the indigo mix later). Wash in some ultramarine from the top downwards as before.

2 The reflection is then created by leaving the appropriate white spaces as you paint the area of water. Unlike the previous technique, this time you should not wet the paper first. Instead you will need a pool of loose cerulean blue ready for the task. Start at the horizon line and sweep the brush from side to side as before but deliberately miss the spaces required for the reflection directly under the boat. It takes an agile brain to do this and lots of practice. It's one of those things that can look brilliant if executed correctly but can be very frustrating as you only get one shot at it.

3 Immediately run in the ultramarine wash from the bottom up as on page 57, taking care to avoid the white reflections.

4 Leave the painting to dry then finish off the boat, using the same methods described in steps 6 and 7 on page 57.

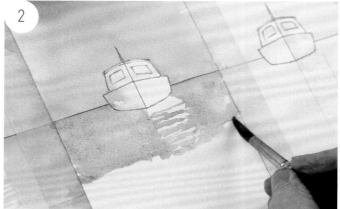

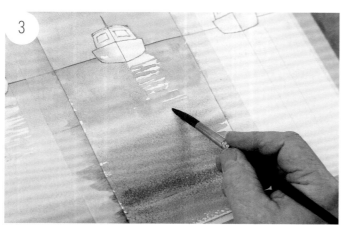

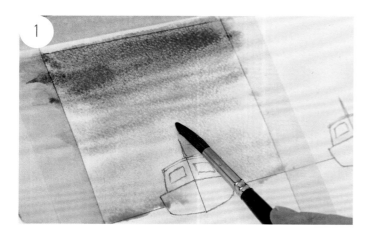

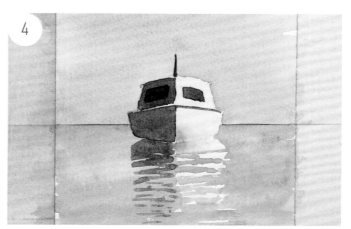

MASKING FLUID

In my view, this is the most satisfactory way to create white reflections. When the dried masking fluid is removed, it leaves pure white marks with lovely sharp edges. However, care must be taken when it is applied to ensure the placement is accurate. Once the background paint has dried, the rubbery masking fluid can be removed by rubbing it with a finger or a soft eraser.

However, masking fluid is not kind to paint brushes: if left in the brush for more than a few seconds, it will start to set and fill the brush head with rubbery 'gunk'. Once a paint brush has been subject to masking fluid, it will never be the same again. So, here are some tips:

- Use an old brush that you won't mind discarding afterwards, or consider using a different type of tool to apply the masking fluid. Some people have success with colour shapers or blenders; often I use a dip pen with a metal nib, especially for finer lines.

- When using a brush, don't 'paint' with the fluid for more than 15 seconds at a time. Keep washing the brush out throughout the process. If you remember to do this, you should be able to use the brush again on another occasion.

1 Apply masking fluid to the right-hand side of the boat – I'm using a small old brush.

2 Apply the masking fluid for the reflections using the same brush. For the narrower lines further down, consider using a tool with a finer end – I'm using a dip pen.

3 Allow the masking fluid to dry completely then paint in the sky and water, following steps 1 and 2 on pages 56 and 57. Dry the painting with a hairdryer, then remove the masking fluid by rubbing it with your finger, as shown.

4 Complete the painting by following steps 6 and 7 on page 57.

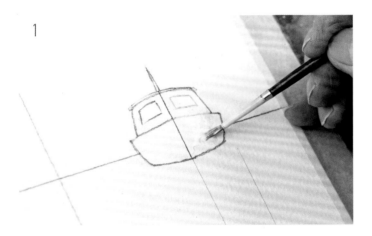

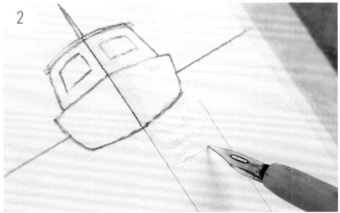

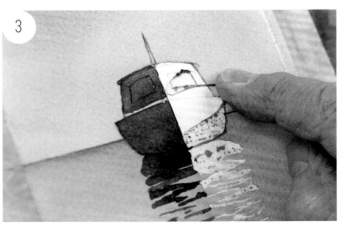

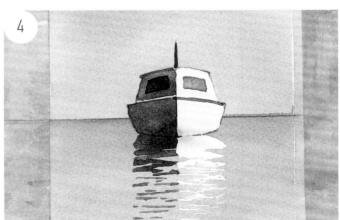

BOATS AT LOW TIDE

You will need

Brushes: size 2 round, size 6 round, size 10 round, 6mm (¼in) flat, mini hake, size 2 rigger

Paints: ultramarine, light red, burnt umber

Paper: 33 x 23cm (13 x 9in) of 300gsm (140lb) NOT, such as Bockingford

Extras: masking tape, paper towel, hairdryer, bevelled ruler (optional)

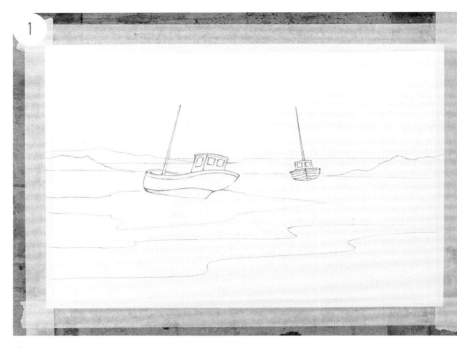

1 MAKING A DRAWING: Draw a horizon line just over halfway up from the bottom of the paper. Create the meandering lines in the foreground; these will form the two pools in the sand. Add the distant headland and the two rocky forms to the right and left of the beach, then a line across where the sand meets the sea. The smaller wooden boat on the right is symmetrical either side of a centre line. To draw the larger boat to the left you can use the guidelines below.

DRAWING MOORED BOATS

Moored boats that are left exposed at low tide make an excellent study. They usually lean to one side and feature the whole of the keel, which would normally be submerged. They are difficult to draw though, so here's an easy method to help with this.

Draw a sideways figure of eight, making the left-hand loop smaller than the one on the right (Fig. **1**). Erase the bottom edge of the right-hand loop (Fig. **2**). Draw in the side and bottom lines, then finish by drawing a box shape on top of the right-hand loop for the boat's cabin (Fig. **3**).

You now have a boat at an angle, ideal for placing on a sandy or pebbled shore. I've added one to this project, with the addition of mast and keel details.

1

2

3

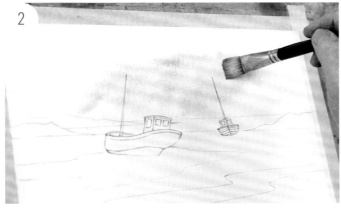

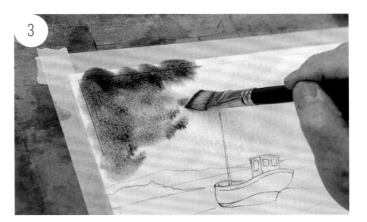

2 Prepare the palette, starting by squeezing out a generous blob of ultramarine and a smaller blob of both light red and burnt umber. Using the size 10 round brush, stir some water into the ultramarine until it is the consistency of olive oil. Then keep stirring in light red, a little at a time, until you achieve a deep plum colour. For now the burnt umber remains untouched. Using the mini hake, wet the whole area of the sky with several brushloads of water until you have an even film of water. Next, pick up a little of the deep plum mix and feather it across the lower central area of the sky.

3 Return to the palette for a little more deep plum. Start flicking this into the sky, starting the brush strokes from the masking tape.

4 Work your way around the whole perimeter of the sky, continually flicking in short brush stokes of the plum mix.

5 Return to the deep plum mix and repeat the last step flicking in some even stronger colour around the edge of the sky. It is important to do this quickly and then allow the paint to mingle and settle naturally.

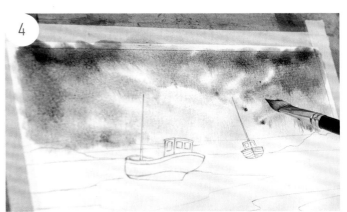

6 The paints should soften, run a little, and create the effect of a squally sky. This can now be dried off with a hairdryer.

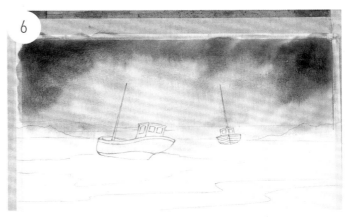

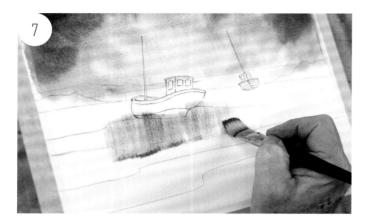

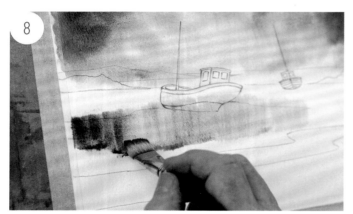

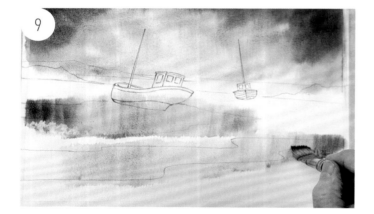

7 There are two pools of water on the beach – one under the boat, and one running across the paper in the near foreground. Both of these pools require reflections of the sky. Refer to the method described on page 33 ('Soft vertical streaks') for this and the next step. Using a mini hake and clean water, wet the pool area under the boat. Pick up a little of the plum mix and apply vertical streaks of colour through the whole pool, overlapping the sand at the top and the bottom.

8 Now to mirror the darker areas of the sky above in the water. In my example, the darker sky was over to the left-hand side of the pool. Immediately pick up some more of the deep plum mix and pull it down through the pool where required, to correspond to the darker area of sky above. (If your sky doesn't have any significant darker areas, you may not need to bother with these extra streaks of the plum mix.)

9 Complete the near-foreground pool in the same way. In my painting, the darker vertical streaks were placed at each end of the pool.

10 Once the reflections in the pools are dry, take a 6mm (¼in) flat brush, fill it with water and gently scrub the paint where it overlaps onto the sand and the boat. Then dab off with a paper towel.

11 Keep doing this until most of the paint has been removed leaving both pools with reasonably sharp edges. Don't worry if you can't remove all of the paint; you can see in my painting that there are still some faint patches.

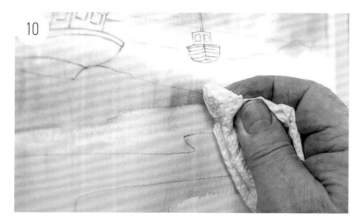

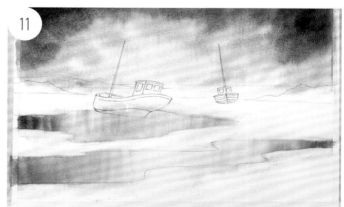

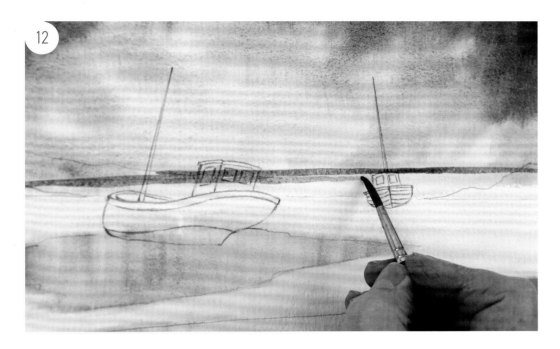

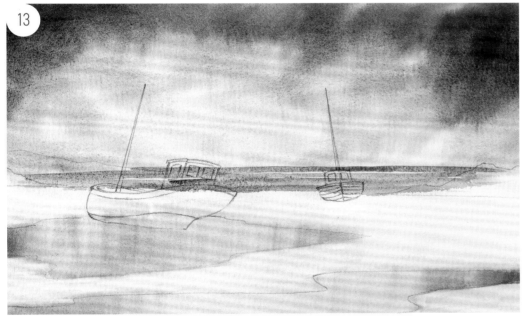

12 To paint the distant sea, you will need to take some of the strong plum mix and dilute it a little. Test the shade on a separate scrap of paper first to check the colour and fluidity. Fill a size 6 round brush with this mix then, using only the tip of the brush, pull the mix across the horizon line to begin shaping the sea. If the cabin on one or both of your boats is on this horizon line, paint straight through it.

13 Keep picking up more paint and create further thin lines underneath the horizon line, leaving the occasional narrow strips of paper showing through to represent waves. Extend the paint onto the land and rocks on each side as you do this.

14 Before painting the beach, add lots of water to the burnt umber until you have a significant puddle of light brown that's the consistency of milk. Make sure there is enough of this mix to complete the whole beach.

15 There are three areas of beach and each one should be painted separately. This is a tricky technique, so starting with the smallest area to the left of the main boat is advisable. Sweep in the light brown mix first with a size 10 round brush.

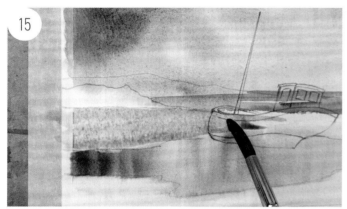

16 Using the size 6 round brush, immediately sweep in a little of the strong plum mix here and there to blend in. To finish off, pick up more of the dark plum mix and then, with just the tip of the brush, carefully run it along the bottom edge of the sand. This should give definition to the lower edge of the sand.

17 The next area of beach is significantly larger. You will need several brushloads of the light brown to cover the whole area of this part of the beach. Work really quickly to avoid the paint drying before the secondary plum mix is blended in.

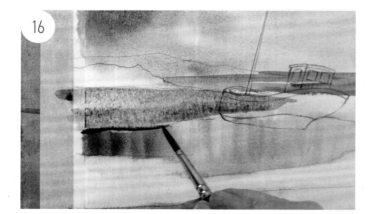

18 As before, immediately sweep a little of the strong plum mix across the sand with the size 6 round brush.

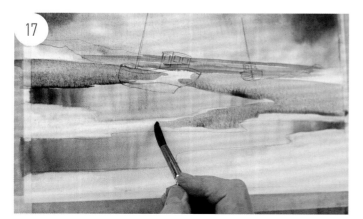

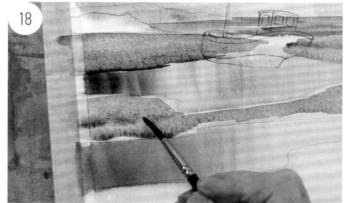

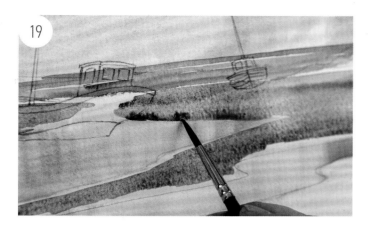

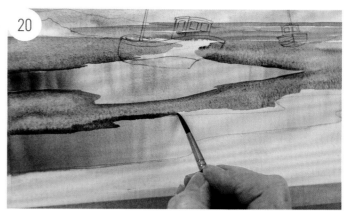

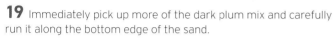

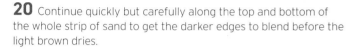

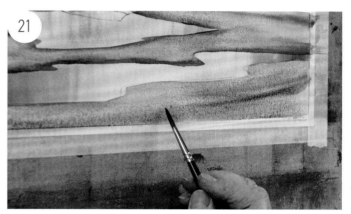

19 Immediately pick up more of the dark plum mix and carefully run it along the bottom edge of the sand.

20 Continue quickly but carefully along the top and bottom of the whole strip of sand to get the darker edges to blend before the light brown dries.

21 The final area of sand is the one running across the whole foreground of the painting. This is slightly easier than the last one as it has only one upper edge. Treat this exactly the same way as the previous two areas of beach.

22 As the areas of sand build up with the blended darker edges, the pools should take on a shine and look like they are full of shimmering water.

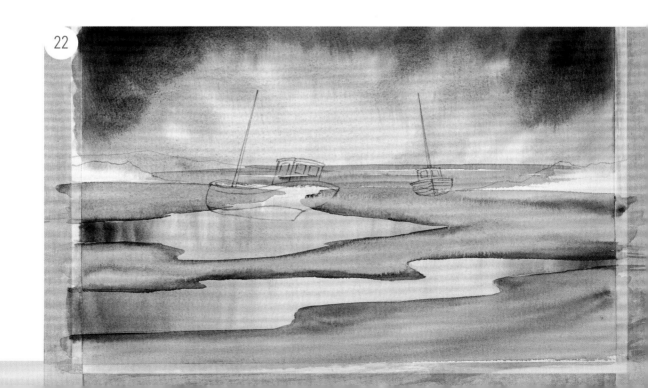

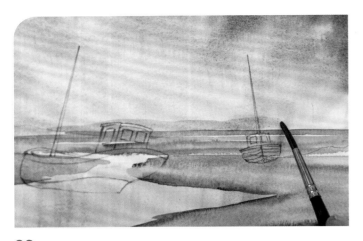

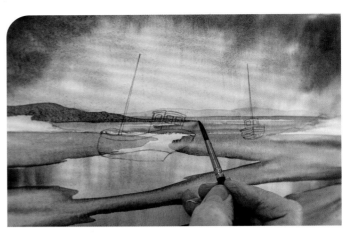

23 Take a little of the plum mix to one side on your palette and add plenty of water to it. Use a size 6 round brush to run this looser mix across the top of the horizon line, just above the sea, to create a distant landform. Dry this off with a hairdryer.

24 Strengthen the plum mix used in the previous stage then run this mix across the horizon line once more, this time from the left-hand edge towards the centre of the picture, to form a darker landform on the left. Pull the paint through the cabin of the boat, and taper it off at the end.

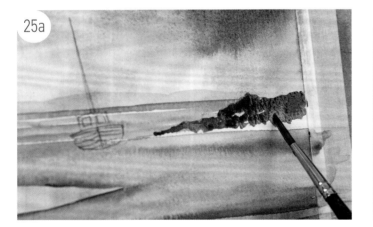

25a

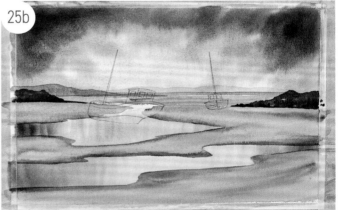

25b

25 The rocks cutting in from the right- and left-hand sides of the beach should be much stronger than the previous landform to give the painting some perspective. Start by filling up the area of the right-hand rock with burnt umber, leaving some tiny patches of paper showing through here and there if you can. Immediately drop in a little of the strong plum mix to blend into the burnt umber (**25a**). Repeat this for the rocks on the left-hand side of the beach (**25b**).

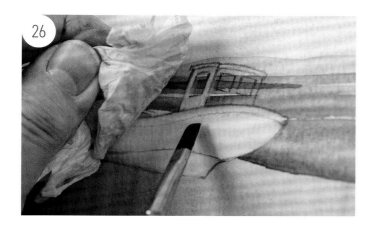

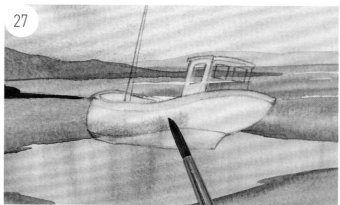

26 Take a 6mm (¼in) flat brush, fill it with clean water, scrub away at the paint that has encroached onto the boat then dab it off with a paper towel. Be careful not to lift out the paint in the cabin windows: you want the distant features to be visible through them.

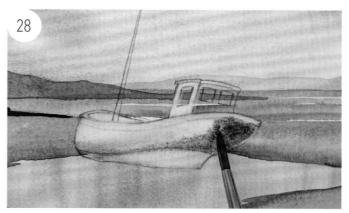

27 Once the boat is clear of paint, fill a size 6 round brush with clean water and spread it out over the whole of the white hull. Pick up a tiny amount of the plum mix and drift it across the underside of the hull, blending it into the clear water just applied. This should suggest a curve in the profile of the hull, and a slight shadow.

28 While the hull is still damp, pick up a stronger version of the plum mix and gently touch this in around the stern (back) section of the hull. Leave this to blend for a few moments, then dry the painting with a hairdryer.

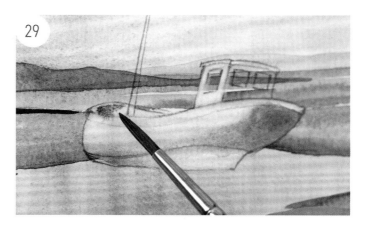

29 There is a small section at the bow (front) where you can see the interior of the boat. Put a small amount of clean water in this area and then touch in a little of the plum mix under the gunwales (top edge of the hull).

30 Use a really strong version of the plum mix to paint the keel (the dark bottom of the boat).

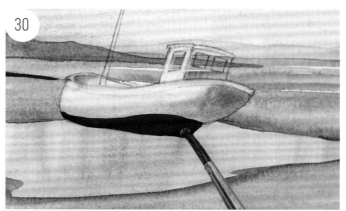

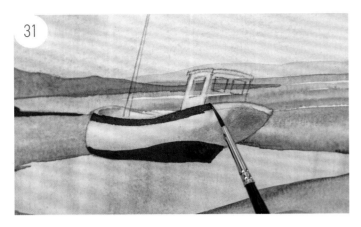

31 With the size 2 round brush and pure light red, paint the trim round the gunwales of the hull.

32 Blend in a little of the plum mix around the stern end of this trim, where there is less light.

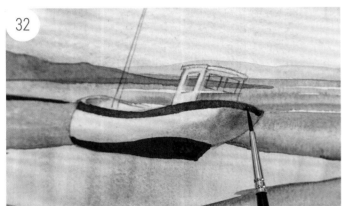

33 Clean the brush then, with some of the light brown (loose burnt umber) mix from earlier, paint the left-hand side of the cabin. Dry this off with a hairdryer.

34 Use a lighter strength of the plum mix to paint the right-hand side of the cabin. Then use a stronger plum mix to paint a narrow line around the internal and external rim of the gunwales. Finish off this boat by running the loose burnt umber (light brown) mix along the roof of the cabin. (If you'd like to see the result, see the boat in the image for step 38, opposite).

35 With the loose burnt umber (light brown), paint the left-hand side of the far-right boat, leaving narrow spaces between each plank in the boat hull if you can. Dry this with a hairdryer.

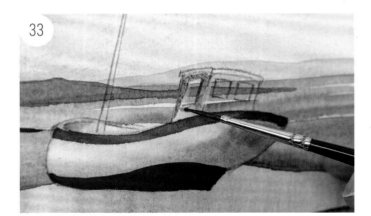

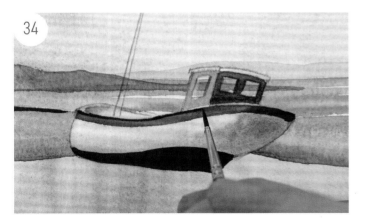

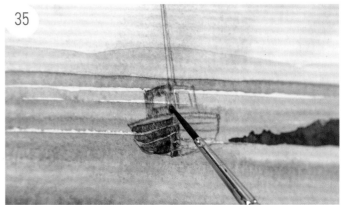

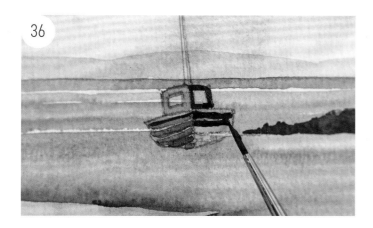

36 Repeat this on the right-hand side of the boat with a stronger version of the burnt umber.

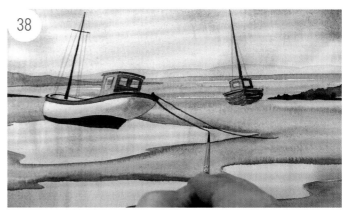

37 Use a size 2 round brush and the strong plum mix to paint the mast and crosspieces freehand, as shown. I find it helpful to rotate the painting by 90 degrees to achieve this, as painting straight lines horizontally rather than vertically is easier, in my view. Of course, you can always use the bevelled edge of a ruler to help you (see page 51). For the rigging, use the same brush but a loose plum mix.

38 Use the strong plum mix and continue with the number 2 brush to sweep across some mooring ropes from either end of the boat. Dry the painting with a hairdryer.

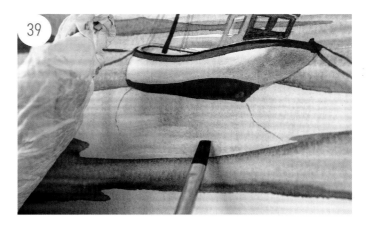

39 Now for the left-hand boat's reflection. With a soft pencil, draw the mirrored shape of the boat in the pool, to act as guide lines. With the 6mm (¼in) flat brush and clean water, scrub away a little of the paint on the bottom-left section of the pool reflection, within your drawn guide lines, then finish off by dabbing the area with a paper towel. This should give the impression of the white parts of the hull reflecting in the water below.

40 To create the reflection of the darker hull, you'll need a strong and loose mix of the plum. With the size 6 round brush and stronger plum, start by painting in the pool area directly below the hull, albeit leaving a small white strip of white at the base of the boat. Quickly wash the brush, fill it with the loose plum and 'scribble' this around the lower area of the reflection, allowing it to catch the darker paint above. The two should blend softly into each other.

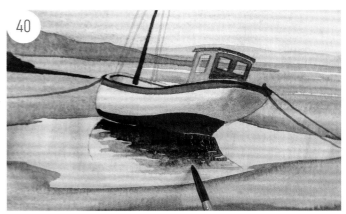

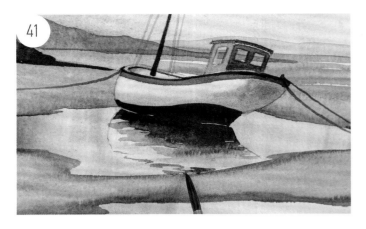

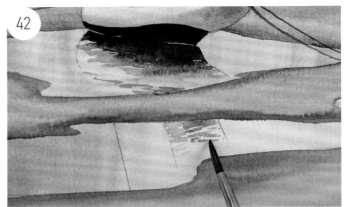

41 Use the size 2 round brush and a little light red to paint a squiggly line at the very bottom of the reflection, to represent the red trim.

42 Draw some guidelines in the bottom pool, aiming to mirror the angle of the boat's cabin. In addition, draw in a guideline for the mast's reflection – again, the angle should mirror the mast above. Begin by scribbling in a reflection for each face of the cabin using the same colours that they were painted with.

43 Then paint in the mast's reflection, over the guideline, 'wobbling' the brush as you work further down. When this is dry, erase all the pencil guidelines.

44 Add some beach details to the scene: with the size 6 round, paint a few clusters of rocks and pebbles using a combination of burnt umber and the strong plum mix (**44a**); with the size 2 rigger and loose plum mix, 'scribble' water runs and seaweed trails (**44b**).

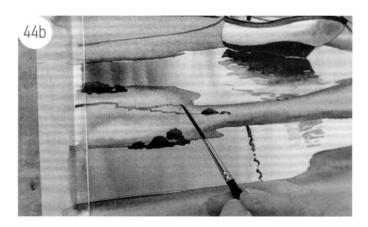

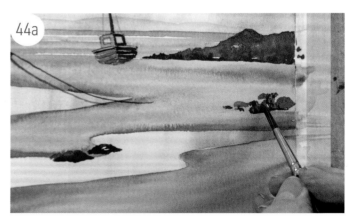

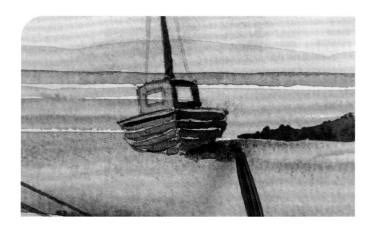

45 Add a shadow to the right-hand side of the distant boat, using the size 6 round brush and loose plum mix.

▼ The result. A few birds added a little life to the scene, placed so they seem like they are hunting for food on the outgoing tide. (See page 23 to see how I paint birds.)

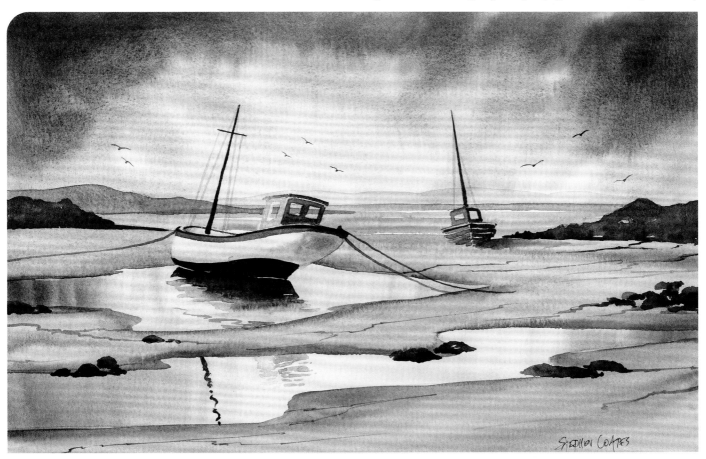

Sea and breaking waves

Painting moving water, like the sea, can be a challenge. The water is highly active, due to the effects of wind and tides but remains reflective despite this. The sea takes on the colour of the sky above but contains flashes of white as waves crest, crash against rocks or scramble onto a beach.

KEY CHARACTERISTICS

MOVEMENT

The waves in the sea are created way out in the oceans then eventually end up on the coast, sweeping onto beaches and smashing against rocks. The energy in a wave as it travels towards land can vary enormously. Waves can crash on the rocks, firing plumes of water into the air, or they might just lap up onto a beach, one gently overlaying another. Whichever the artist chooses to depict, the difficulty in painting waves lies in capturing a single moment from a rapidly changing subject.

Is it possible to represent this energy and movement in a still image? The answer is yes but it does require some study and practice. It is important to examine the shapes, colours and forms created by the moving water before having a go at getting it down on paper.

WHITE SHAPES

Active sea water contains a lot of white. As a wave rises, the crest breaks apart into a mass of droplets and bubbles, which scatter the surrounding light in every direction, hence why it looks white. After a wave has broken, a thin layer of white foam covers the surface of the sea which gets stretched and pulled apart by the movement of the water. This white sheet of foam breaks up into a network of stringy shapes before disappearing back into the water. A study of these white marble-like strands and the darker shapes in between is crucial if you want to try to capture the energy of breaking waves.

REFLECTIONS

Generally the open sea has too much movement for there to be discernible reflections; however, it still has reflective properties. When the sky is blue, the sea will take on a deep blue colour; when the clouds are dark and stormy, the sea becomes a deeply oppressive shade. In fact, with a heavy sky, the sea can look quite black apart from the white flashes on the crests of the waves. Where the sea is calm, for example in a harbour, it will behave just the same as a lake or river and can produce sharp, vivid reflections.

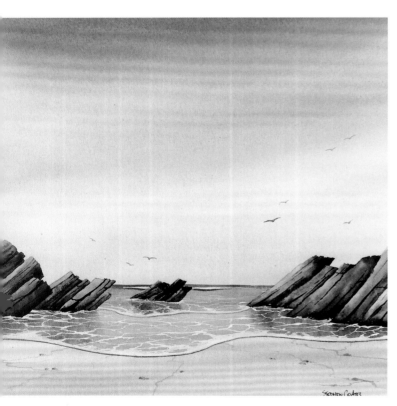

Basalt Beach
35 x 35cm (14 x 14in), Bockingford NOT 425gsm (200lb)

The inspiration behind this painting came from observing the beautiful shapes and textures of waves as they reach the end of their long journey, along the water's edge. The basalt columns rising from the beach form a sharp and rugged contrast to the soft curves of the lapping waves.

FOAMING WATER

As a wave rises, turns and breaks, it forms a crest of foam along the top edge. Many might assume that this should be painted with a white medium, such as permanent white gouache. This is possible, of course, but most would agree that the effect is best created by leaving white spaces of paper. However, the roll of white foam needs to have form with shadows and soft edges. The following technique will show you how to achieve this. If you want to try it, you will need cerulean blue, ultramarine and lemon yellow paints; watercolour paper; a soft pencil and a soft eraser; some paper towel; an old cloth or rag; and a size 8 round brush.

1
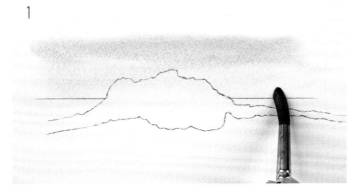

2
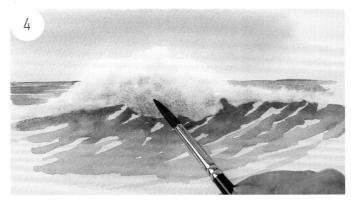

3

4
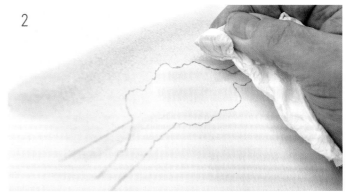

1 Use a soft pencil to draw a horizon line interrupted by a rising wave. The pencil lines are a guide and will be erased later. With the brush, wet the area of the sky with water then immediately sweep across some cerulean blue, covering the top of the wave.

2 While this is wet, scrunch up a paper towel and gently dab the blue paint off the rising wave. Use the lightest of touches to prevent creating any sharp edges. The pencil lines should be fully exposed so that they can be erased after the paint has dried. The distant sea on either side of the wave is split into two areas, so do each one in turn. Paint some loose ultramarine along and below the horizon line, leaving a few narrow gaps to suggest distant waves. Ensure the paint extends into the wave. In the same way as before, gently dab the paint off the white foam. If the paint is stubborn, you may need to 'scribble' it with a clean, wet brush and dab again. Painting the sea underneath the wave is covered on page 75.

3 Make sure the painting is dry before erasing the pencil lines. Create a loose puddle of cerulean blue then stir in a touch of lemon yellow to produce a turquoise colour. Also create a slightly stronger puddle of ultramarine and stir in a little lemon yellow to produce a deep sea green colour. Now to create the shadows in the foam: fill the whole white area with plenty of clean water, then immediately dab in some of the turquoise and sea green mixes, focussing on the lower part of the wave.

4 Quickly wash the brush, dab off the excess water on an old cloth or rag then delicately 'scribble' across the wave with the brush to soften the colours in the foam's shadow. If you feel the shadow is understated, add a touch more paint and repeat the process.

WHITE MARBLING

After a wave has broken, the white foam spreads out and gets pulled apart by the movement of the sea. The foam breaks up into a network of stringy shapes before disappearing back into the water. This stretching foam takes on a pattern similar to that which can be observed in marble. A study of this white marbling and the darker shapes in between is important if you want to try to capture the movement of breaking waves. There are three approaches to this and I have explored them here for you to try. You can then perhaps choose your favourite method.

As before, you will need watercolour paper; a pencil and soft eraser; some paper towel; an old cloth or rag; a size 8 round brush; and ultramarine, cerulean blue and lemon yellow paints. You will also need a hairdryer.

DRAWING METHOD

1 First, draw a horizon line with a rolling wave just below it. The pencil lines are a guide and will be erased later. The distant sea is painted with loose cerulean blue, down into the top of the rolling wave. Then, along the top edge of the foam, gently lift out the cerulean blue (as in step 2 on page 73). The stretched web of white lines in the water, below the foaming edge, should have a tint of colour, so an underwash of extremely loose cerulean blue should be applied first to the whole area. Dry the wave thoroughly with a hairdryer. Use a soft pencil to draw a pattern of faint marble-like lines.

2 Create a loose turquoise colour by adding a tiny spot of lemon yellow to cerulean blue with plenty of water. Also prepare a thicker mix of pure cerulean blue on the palette. Fill an area between the marble lines with the loose turquoise then touch in a little of the stronger cerulean blue at the top to create a shadow cast by the overhanging foam. This should be allowed to blend into the loose turquoise mix.

3 Fill in the rest of the spaces inside the marble outlines in the same way. Avoid the pencil lines, but don't worry about being too neat; the marbled water would look too artificial otherwise.

4 Dry the painting with a hairdryer then erase all pencil lines to see the end result. You can then complete the foaming wave using the method described in steps 3 and 4 on page 73.

1
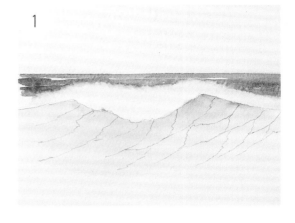

2
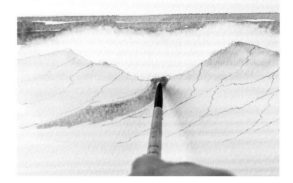

3
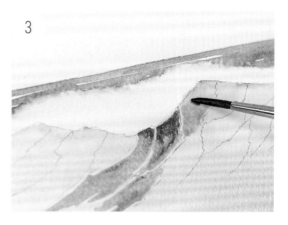

4
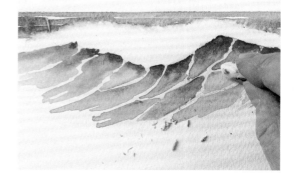

NEGATIVE PAINTING METHOD

1 Create the initial drawing, then prepare and paint the sky and distant sea as per steps 1 and 2 on page 73. Make up a loose puddle of turquoise and a strong puddle of sea green as described in step 3 on page 73. Wet the underside of the wave then apply a base wash as described in step 1, opposite, this time using the loose turquoise mix. Dry it with a hairdryer.

2 Fill the brush with some of the loose turquoise mix and swish it around the wave area, leaving random narrow spaces to represent the marbling. Do this quickly and keep loading the brush as you progress to ensure it stays wet.

3 Immediately fill the brush with some of the strong sea green and touch it into the turquoise directly under the wave. Gently flick this down to encourage it to blend into the turquoise.

4 The result. This technique is somewhat more challenging to execute but in my view it has a more natural look.

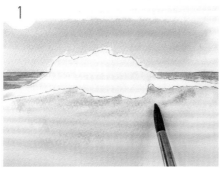

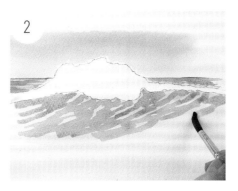

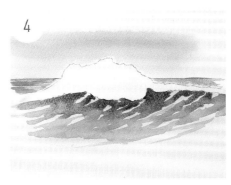

WHITE MEDIUM METHOD

There are times when adding a more opaque white medium can work really well. This is particularly the case when the pattern of the marbling is intricate or a spray is required. Options for the white medium include white acrylic paint, calligraphy ink or permanent white gouache. White watercolour paint is not suitable because it simply doesn't have the opacity to cover darker paint.

In these examples and in the following project I have used permanent white gouache. Straight from the tube it will be too thick to create fluid lines, so you'll need to add a touch of water to the gouache to enable it to flow. Too much water, though, and it will fade as it is overlaid.

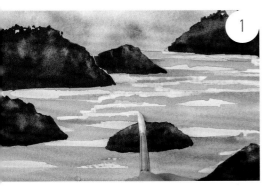

1 Having painted a composition featuring a crashing wave and some rocks, I had already left a few negative spaces in the foreground area of the sea. I chose to enhance this by trailing some further white lines across with a size 2 round brush filled with white gouache.

2 I also flicked a few brush strokes up onto the rocks to represent some splashing foam. The final result can be seen on page 76.

SEA SPRAY

Permanent white gouache is useful for creating the effects of sea spray, which typically occur when waves crash against hard surfaces like rocks. I've found the best way to achieve this is to flick gouache onto the painting with the help of a ruler and toothbrush.

Take a toothbrush, wet it with clean water and stir it into a small blob of gouache on your palette, pressing down quite hard until the bristles are filled with paint. The water on the brush should dilute the gouache too. Rest the bristles on the edge of a small plastic ruler then pull back the ruler quite aggressively against the bristles. This releases a spray of paint onto the painting (see the two top-right images).

You will need to experiment with this technique to get the consistency of the paint right and to determine the ideal angle of the toothbrush: if the gouache is a little too wet, it might fly out of the toothbrush in blobs rather than as a fine spray.

1 I created a painting using some of the earlier methods. The foreground rocks were painted by blending loose and thick versions of a burnt umber-ultramarine mix. I used the toothbrush to add some spray to the rising waves; I flicked some gouache here and there over the rocks as well.

2 The end result is a really energetic representation of the power of the sea!

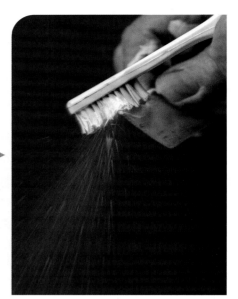
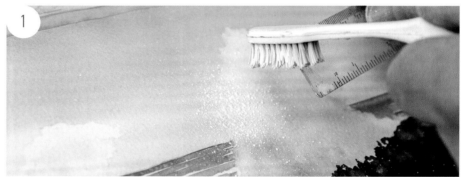
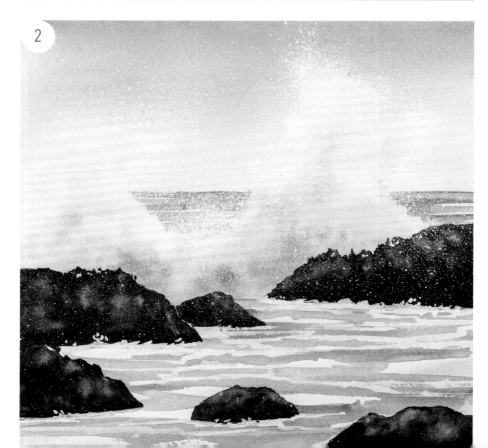

BEACH AT SUNSET

You will need

Brushes: large hake, mini hake, size 2 round, size 8 round, size 10 round, 12mm (½in) flat, 6mm (¼in) flat, size 2 rigger

Paints: ultramarine, burnt umber, alizarin crimson, raw sienna

Paper: 33 x 23cm (13 x 9in) of 300gsm (140lb) NOT, such as Bockingford

Extras: masking tape, pencil, hairdryer, chosen white medium (I'm using permanent white gouache, but you could use white calligraphy ink or white acrylic paint), dip pen and nib (optional)

1 MAKING A DRAWING: Use a soft pencil and draw a partial horizon a little below the halfway point. Draw a series of overlapping rocks and soft curved lines to mark the advancing edges of the overlapping waves.

2 PREPARING THE PALETTE: Squeeze out a generous blob of ultramarine and alizarin crimson onto a palette. Also squeeze out a blob of raw sienna and burnt umber. Start by adding some water to the ultramarine and stirring all of it into a puddle the consistency of olive oil. Stir in plenty of the alizarin crimson until a deep lilac colour is achieved. This will look almost black on the palette so I suggest you touch some onto a scrap of paper and add a little water to see how it will look when diluted.

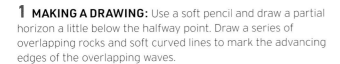

3 Steps 3-6 should be completed within a couple of minutes before the paper dries. Wet the sky area with an even film of clean water and the large hake, working slightly below the horizon line. Pick up some raw sienna and sweep it across the lower area of the sky, working slowly upwards.

4 Immediately pick up some of the lilac mix and sweep this gently with horizontal brush strokes across the top of the sky, working from the top downwards and descending until the colour fades about halfway down.

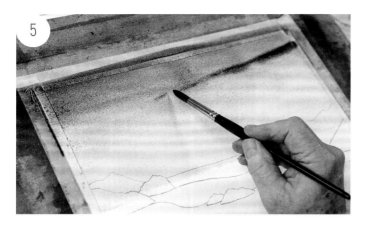

5 Immediately, pick up a little of the strong lilac with the damp size 10 round brush and gently stroke in a long cloud; this should taper at the end, beyond the centre of the painting, as you lift the brush away.

6 Keep adding more clouds from the edges of the paper in the same way, making sure the ends diminish in size towards the centre of the paper. Touch some more strong lilac into the outside edges of the uppermost clouds to give them more depth. Leave the paint to settle for a minute or two, then dry the painting with the hairdryer.

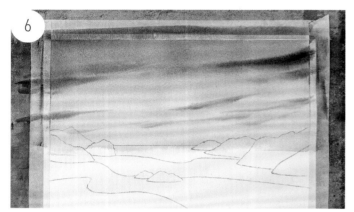

7 To create the beach, the process is very similar. Wet the whole area below the horizon line with the large hake and clean water, then pick up plenty of the raw sienna and sweep it in from side to side, spreading it out evenly.

8 Immediately pick up a little of the lilac mix with a damp size 10 brush, hold it at a low angle and sweep a few broad lines into the raw sienna from the edges of the paper, focussing on the immediate foreground area.

9 While this is all still wet, wiggle the tip of the damp brush across the blob of burnt umber to dilute it a little then gently sweep a few lines of this across as well, in the same way as before. The three colours should blend together to form a soft, variegated wash.

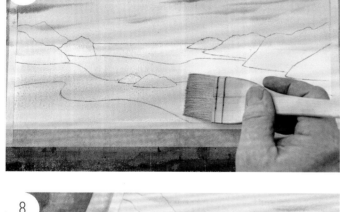

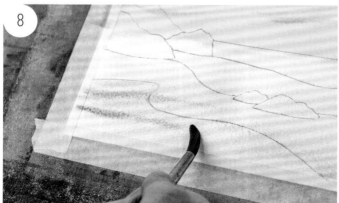

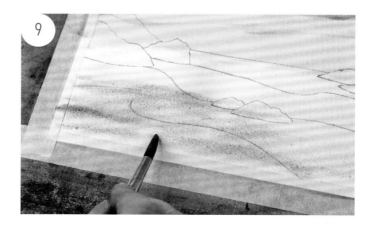

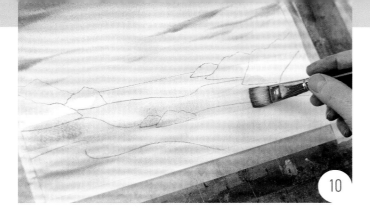

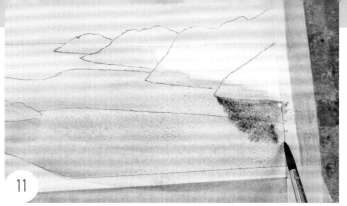

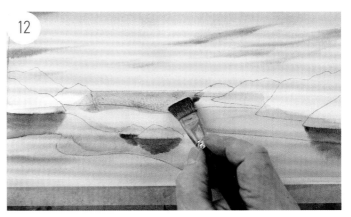

10 The following stages involve placing the layers of waves as they creep over the beach. The blurred reflections of the rocks have to be painted during these steps too. This is a little complicated so please read all the instructions for steps 10-14 carefully before starting. You will also need to create a few new mixes. Squeeze out another small blob of ultramarine. Stir some water into the blob of burnt umber until it is the consistency of olive oil. Now stir in some ultramarine until you achieve a dark chocolate brown colour. This is for the rocks and their reflections. Take some of the strong lilac mix to one side and add plenty of water to it until it is the consistency of milk. This will form the basis of the lapping waves.

Now, fill the mini hake with the milky lilac and gently ease it across the whole area of all the sea, from the horizon right down to the edge of the foreground wave. This is a large area, so you will need two or three brushloads of this paint. Don't worry if some of the beach colour underneath comes away.

11 Immediately pick up some of the dark brown with a damp size 8 round brush and 'scribble' some reflections under the four nearest rocks, one on the extreme right (pictured), one on the extreme left and the two smaller central ones (you can see the result of this in image 12). The reflections will mirror the shape of the rocks, so should narrow towards the bottom; the paint should suffuse and blur into the wet lilac wash. Dry with the hairdryer.

12 Now add a little of the stronger lilac to the milky lilac to strengthen it slightly. Gently wash this in over the sea with the mini hake, from the horizon line down to the front edge of the second wave. Don't worry if you catch the edges of the rocks with this mix.

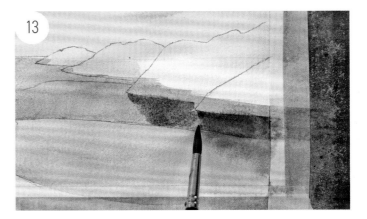

13 As before, use the size 8 round brush to scribble in some reflections under the two rocks. One on the right hand side...

14 ... and one to the left. Dry the painting with a hairdryer.

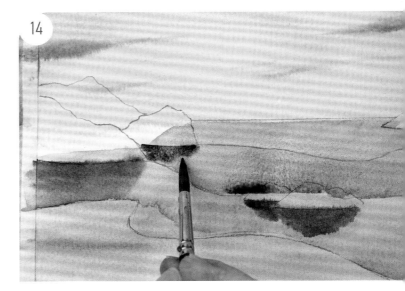

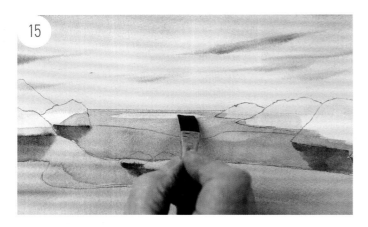

15 Lift out a long strip of paint towards the upper part of the sea by 'scrubbing' the area with a clean, wet 12mm (½in) flat brush then dabbing with a paper towel.

16 Add some more of the strong lilac to the thinner lilac to strengthen it for a second time. Fill the size 8 round brush with this and carefully paint along the horizon line.

17 Fill in the rest of the sea area with the same mix, down to the edge of the farthest wave. You will need to keep filling the brush as you work, and make sure you leave the strip of white you lifted out in step 15, to represent a distant breaking wave.

18 Immediately drop in a little of the dark brown under the two distant rocks on the right. At this stage the painting will look a bit of a mess (just like mine!). Don't worry about this; you are still laying down the foundations and it will come good at the end!

19 Once all this is dry, run a smooth dark line across the front edge of the immediate foreground wave with the size 2 round brush and the strong lilac mix.

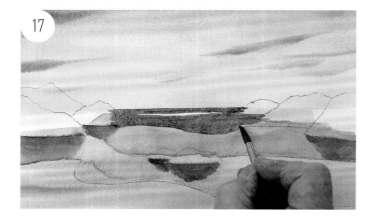

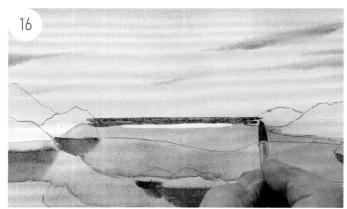

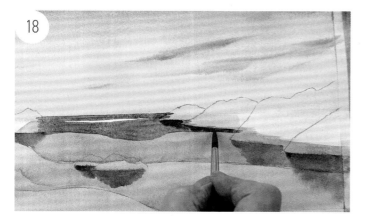

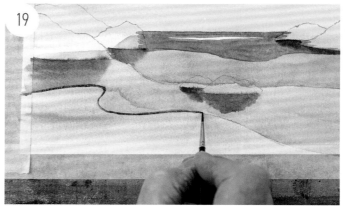

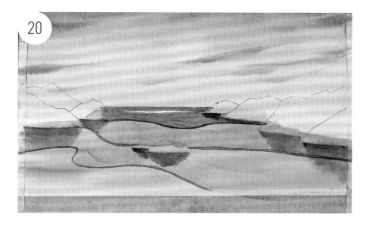

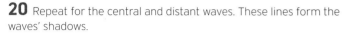

20 Repeat for the central and distant waves. These lines form the waves' shadows.

21 There will now be quite a lot of paint on the rocks so this will need to be removed. Fill the 6mm (¼in) flat brush with clean water, use this to 'scrub' at the paint inside the rocks then and dab off the rest of the paint with a paper towel. Try to remove the paint that sits over the pencilled outlines, so that these can be easily erased.

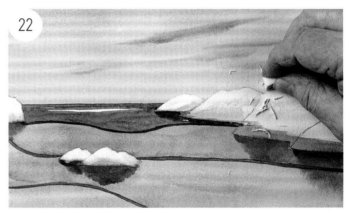

22 Dry the painting with a hairdryer, then erase the pencil lines around the top of the rocks.

23 Each rock should have a lighter top edge; they then gradually get darker towards the base. The dark paint used should slightly overlap the rock in front of it, creating a crisp top edge. Therefore the first rocks to be completed should be those in the foreground; then you work gradually towards the distant rocks. You will need a puddle of loose raw sienna, the strong lilac and some of the strong dark brown.

Using the size 8 round brush, fill the whole rock with some of the loose raw sienna then flick in a little of the strong lilac here and there from the top of the rock, allowing the two mixes to blend.

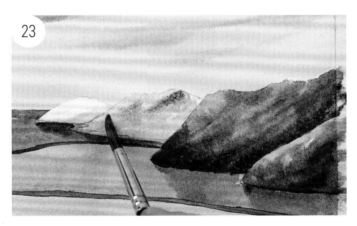

24 Immediately plunge the brush into the dark brown then work this in from the bottom of the rock upwards. The lighter top edge of the rock in front will be brought forwards, against the intensity of this darker paint.

Complete all the rocks in the same way, one by one, drying each rock with a hairdryer before starting on the next to avoid the paints bleeding into each other.

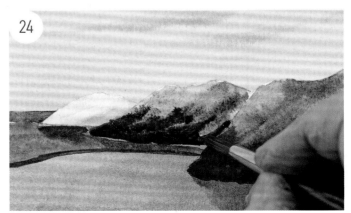

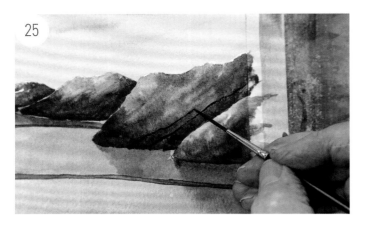

25 When all the rocks have dried, use some of the dark brown and the size 2 rigger to paint on some cracks and strata lines, being careful not to overdo it. Try to vary the distance between the lines to make them look more realistic, and to prevent them looking like stripes. The lines in the rocks should be a little rugged and run at a similar angle on all of them.

26 With the size 2 round brush and strong lilac mix, paint a narrow shadow under the distant wave; this will give it depth. The painting should now make more sense, but the next stage will transform it completely.

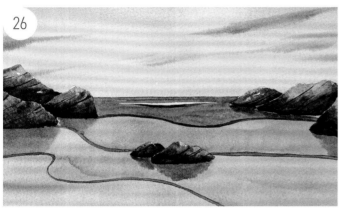

27 With the main scene in place, the white marbling foam can now be added. This is done with permanent white gouache. Squeeze out a blob of the gouache and stir in a tiny amount of clean water with the size 2 round brush – it should be just soft enough to paint with, but not runny; if there is too much water in the gouache, it will become transparent. You may find it easier to turn the painting upside down to complete this stage. Using the same brush, create a line of foam along the leading edge of the wave. This should be neat on one side and overlap the shadow line, reducing it to a narrow pinstripe. On the other side of this line of foam the paint should be 'scribbled' in a bit to produce an uneven edge where it will break into a web of marble-like veins.

28 Repeat this on the leading edge of all three waves.

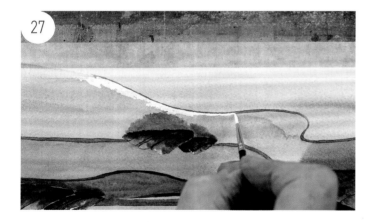

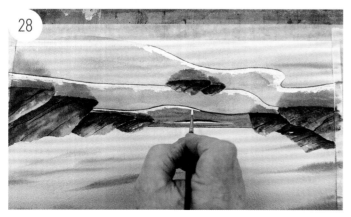

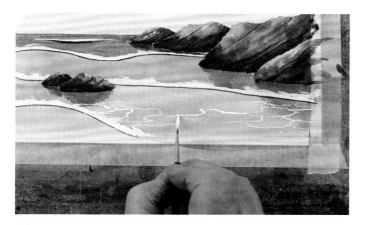

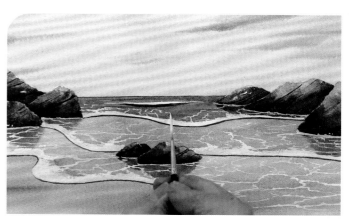

29 With the same gouache mix and the size 2 rigger or dip pen and nib, create a web of marbling lines that spread from the foamy edge of the wave in the immediate foreground and taper off towards the next approaching wave. These lines are achieved by 'wobbling' the brush as you paint.

30 Repeat this process over the next two waves. You can use these lines to cover any ugly streaks or watermarks that may have occurred when you painted the overlapping waves originally. if you wish, flick a little gouache around the bases of the rocks to suggest small waves gently crashing against them.

▼ The finished painting. The small flock of birds, painted with the strong lilac mix and size 2 rigger, is entirely optional! See page 23 for an easy method of painting birds in flight.

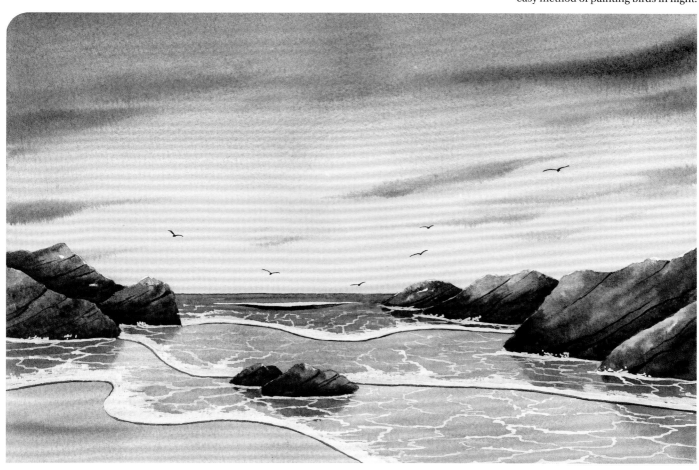

WATER FOUR
Sparkling water

When light sparkles on the surface of water it is because two particular conditions have occurred at the same time. One is the sun shining directly towards the viewer from the back of the scene. The other is a strong gust of wind blowing across the surface of the water, making strong ripples. The ripples fragment the reflection and create a lovely sparkling, shimmering effect.

Under normal circumstances, this effect is something that we can't observe comfortably due to the strength of the sun in our eyes. Everyone knows it is dangerous to look directly towards the sun, especially when it is reflecting off the water, as it gives our eyes a double dose of damaging ultraviolet light. Photographers also find these light conditions challenging and have to make adjustments to the camera accordingly in order to get a decent picture.

▼ In the left-hand photograph, it is easy to observe the light at the back of the scene reflecting off the surface of the water, creating a sparkling effect. The sun is out of shot and quite high in the sky.

In the right-hand photograph, a strong burst of sunlight is emerging from behind the clouds and shining through gaps in the clouds onto the surface of the water. This is a really dramatic scene that makes for an exciting painting opportunity.

In both images, the most important feature to note is how much white light there is in the water. These bright areas also contain a scattering of the darker reflected clouds, and the challenge for the watercolour artist is to capture this effect. Luckily rough watercolour paper has a surface texture that artists can use to their advantage, to represent this shimmering effect.

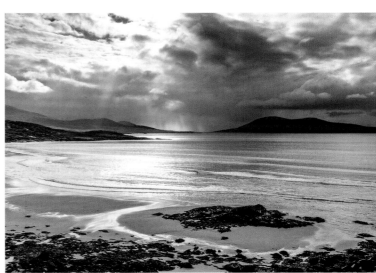

A NOTE ABOUT WATERCOLOUR PAPER

The technique used to create sparkling water will only work on a textured surface, so you will need to use cold-pressed paper – hot-pressed paper, which is smooth, will not be suitable. The sparkling effect can be exaggerated by choosing cold-pressed paper with a 'rough' texture. More information about this can be found under 'Texture' on page 25.

TECHNIQUE

CREATING SPARKLING WATER WITH A DRY BRUSH

In an earlier project (see page 47), I created a foreground gravel beach using a dry-brush technique. This technique can also be used to produce a sparkle on the surface of the water.

In most circumstances, a watercolour brush should be fully loaded with plenty of paint to encourage a healthy flow onto the paper. This paint will cover all the bumps on the paper and also run into all the depressions, resulting in an overall granulated finish. To create a 'sparkling' effect the brush should be prepared more sparingly, so that the paint only catches the bumps on the paper and doesn't flow so readily into the depressions. The resulting white gaps are what create the illusion of sparkling water. The volume of paint in the brush will determine the flow and this requires some experimentation to get a feel for it.

The angle of the brush to the paper is also another key factor in achieving the dry-brush technique, and this is covered in detail on page 21. In Fig. **a**, the brush is being held at a really low angle so that the side is in contact with the paper but not the tip. What you see is a single brush stroke made from left to right. In Fig. **b**, I have lifted the brush angle slightly, bringing the tip and some of the side of the brush into contact with the paper. I have applied a little more pressure and 'scrubbed' the brush against the paper several times, from side to side.

To summarize, the volume of paint in the brush head, along with the angle and motion of the brush, are all important and require some practice. The following exercise provides an opportunity to experiment with this technique.

a

b

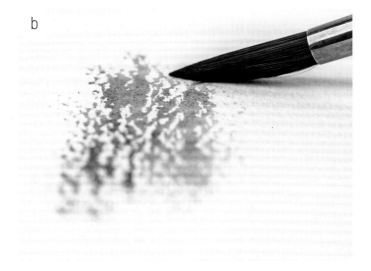

EXERCISE: DRY-BRUSHED SPARKLING SEA

Using the left-hand photograph on page 84 as a reference, I created a basic composition to help you get to grips with the dry-brush technique. You could try this on a smaller sheet of paper than the one suggested, and then repeat the process several times. The whole painting should only take a few minutes to complete.

You will need

Brushes: mini hake, 6mm (¼in) flat, size 8 round, size 2 rigger (optional)

Paints: cerulean blue, ultramarine, lemon yellow, light red

Paper: 28 x 19cm (11 x 7½in) of 300gsm (140lb) rough paper, such as Bockingford

Extras: masking tape, hairdryer, paper towel

1 Using the mini hake, wet the whole area of the sky and slightly below the horizon, making sure you have an even film of water across the paper. Pick up plenty of pure cerulean blue with the tip of the damp mini hake and sweep this into the sky area. Start at the top and sweep the brush from side to side, gradually working down to just below the horizon line. The intensity of blue should fade towards the horizon. Dry this with a hairdryer.

2 Any paint below the horizon line now needs to be removed. With a clean wet 6mm (¼in) flat brush, scrub at the paint then dab the area with a paper towel.

3 With the size 8 brush, add some water to the cerulean blue and stir it into a puddle the consistency of double cream (heavy cream). Stir in a touch of lemon yellow to produce a turquoise colour - not too much, otherwise it will turn emerald green.

4 Before creating the sparkle using the dry-brush technique, take a piece of the rough watercolour paper and test that the level of paint in the brush is correct.

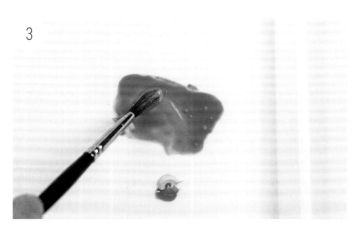

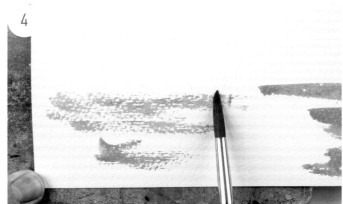

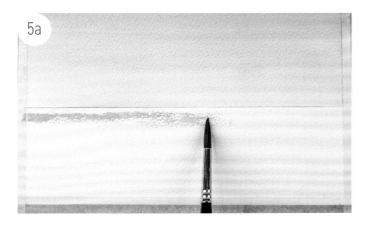

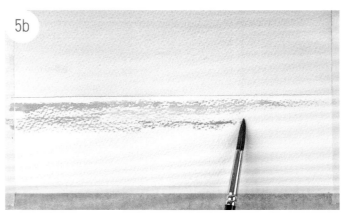

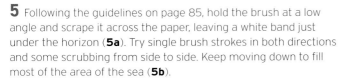

5 Following the guidelines on page 85, hold the brush at a low angle and scrape it across the paper, leaving a white band just under the horizon (**5a**). Try single brush strokes in both directions and some scrubbing from side to side. Keep moving down to fill most of the area of the sea (**5b**).

6 As the broken effect develops, try lifting the angle of the brush here and there to produce a few more solid lines with the tip.

7 If you want to take the exercise further, stir water into a blob of ultramarine and add a little light red to produce a plum colour. Put some of this to one side on the palette and add plenty of water to get it loose. With the size 8 brush, paint some distant islands with the loose plum mix, starting from one side and working in one flowing motion without going back.

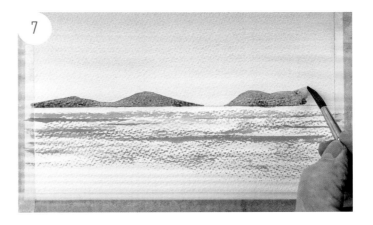

8 To create a bit of foreground, use the stronger plum mix and scrape across from the left hand side of the beach, utilizing the same dry-brush technique as before. I added a couple of birds to the scene to finish it off. (See page 23 for more information about painting birds.)

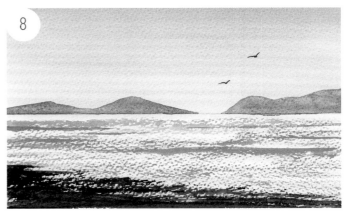

STORMY ISLAND BEACH

■■■□ ADVANCED TECHNIQUE

ADAPTING A REFERENCE IMAGE

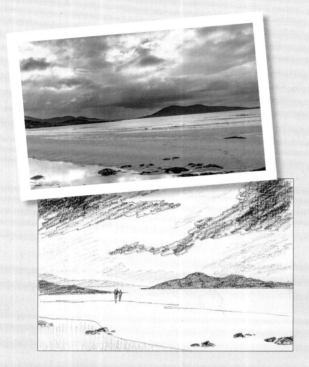

This project is based on the photograph above. The light is at the back of the scene and is reflecting off the sea as it breaks through the clouds, creating a sparkle. I produced a sketch of the scene but made a few adjustments, notably the simplification of the sky – the clouds in the photograph were a little complicated so I decided to sweep in some stronger storm clouds from the outer edges of the frame, leaving plenty of light areas centrally. I also increased the sea area a little to enhance the sparkling effect, moved the nearest left-hand headland down a touch to provide better separation and added a couple of human figures. Note the different shades in the sketch; this helps me create and select the best paint mix consistency for the different parts of the scene.

You will need

Brushes: mini hake, 6mm (¼in) flat, size 2 round, size 6 round, size 8 round, size 10 round, size 2 rigger

Paints: ultramarine, burnt sienna, burnt umber

Paper: 33 x 23cm (13 x 9in) of 300gsm (140lb) rough paper, such as Bockingford

Extras: masking tape, hairdryer, paper towel, soft eraser, pencil

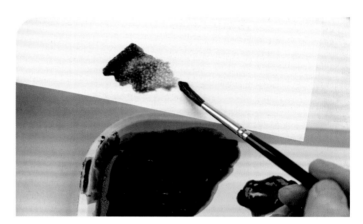

1 MAKING A DRAWING AND PREPARING THE PALETTE:
I always recommend painting a sky first before completing the rest of the drawing, so you need draw only a horizon line for now, just over a third of the way up. Squeeze out generous blobs of ultramarine and burnt sienna. You will also need a small blob each of burnt sienna and burnt umber. Stir in several brushloads of water to all of the ultramarine until it is the consistency of olive oil. Now stir in plenty of the burnt sienna until a warm grey is achieved. At this point the mix will be thick and look almost black. Touch a little of this onto some sample paper, then add some water and spread it out, as pictured. This will give a true indication of the colour once it has diluted on the paper.

TIP
A prepared mix will look darker on the palette than after it has been applied to pre-wet paper. To test it, put a small sample of the mix onto a scrap of watercolour paper, add some water and spread it out.

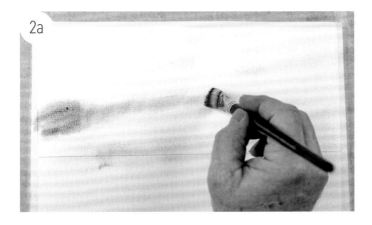

2a

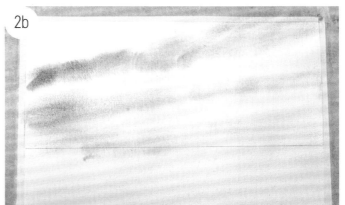

2b

2 Once the paper has been wet, the whole sky should be completed quickly before the water evaporates. With a mini hake, cover the whole area of the sky with an even film of water. Pick up a small quantity of the warm grey mix and sweep two bands of this through the lower area of the sky, leaving a white space between them (**2a**). Add another band of the warm grey mix across the upper area of the sky again, leaving a white space (**2b**). The two white spaces will form the areas of the sky where the light penetrates through the clouds.

3 Immediately pick up more of the warm grey mix and gently stroke in a darker cloud across the top left-hand corner of the sky, avoiding the upper white band. In a similar way, form a cloud that starts in the top right-hand corner then gradually tapers to a point between the two white bands.

4 While there is a minimal amount of paint left in the brush, trail in a few delicate clouds with the corner of brush, from the right-hand side of the painting to just above the horizon.

5 To finish off, plunge the brush back into the warm grey mix and flick a few dark brush strokes into the upper clouds. Once this is in, don't fiddle with the sky any further and leave it for a few minutes so the paint can settle. There should be plenty of light space in the central area.

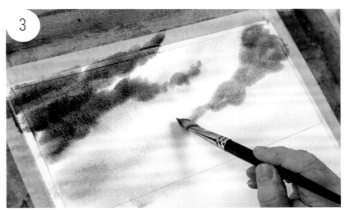

3

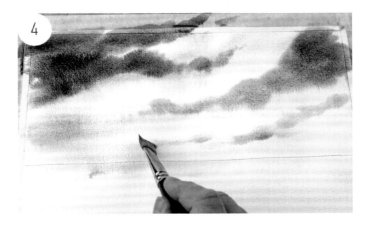

4

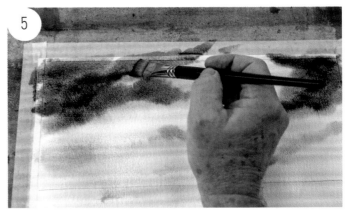

5

TIP
Even with a complicated sky, once the paper has been wet, the paint should be applied and completed within around two minutes. This allows time for the pigments to disperse, separate and granulate before the water evaporates. In steps 4 and 5, you can clearly observe some of the burnt sienna separating from the grey mix; this creates a creamy tint around the edges of the clouds.

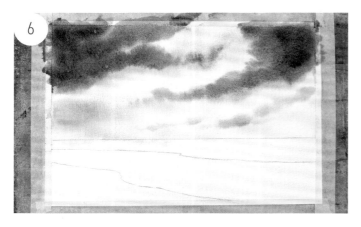

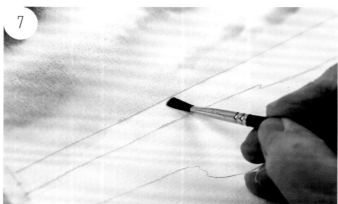

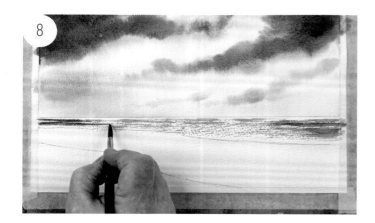

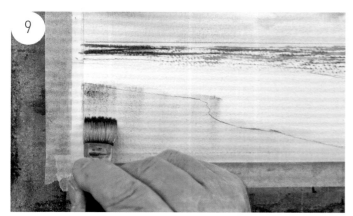

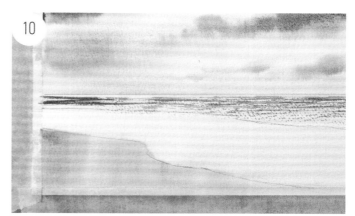

6 Once you are happy with the completed sky, dry the painting with a hairdryer. Then, draw two meandering lines below the horizon; these form the edges of the sand.

7 Any paint below the horizon line now needs to be removed. With a clean, wet 6mm (¼in) flat brush, scrub at the paint then dab it away with a paper towel.

8 Referring to the technique and exercise on pages 85–87, use a size 8 round brush and the warm grey mix to create the sparkling sea. Keep a band of white directly below the horizon and along the water's edge. Use the tip of the brush to create a few darker lines towards the left- and right-hand side of the sea, retaining light in the central area.

9 Referring to the 'Soft vertical streaks' technique on page 33, create the reflections of the clouds in the foreground pool on the beach. With the mini make, first wet the area of the pool with clean water, pick up some of the warm grey mix then, with the brush head horizontal, pull down some streaks. Start the brush strokes in the sand above, to ensure they pass all the way through, into the masking tape at the bottom. Try to get a couple of darker streaks on the left-hand side. (You can see a mystery blemish on my paper to the left. This was covered later with a rock!)

10 The extended brush marks on the sand can now be removed. With a clean, wet 6mm (¼in) flat brush, scrub at the paint then dab it away with a paper towel.

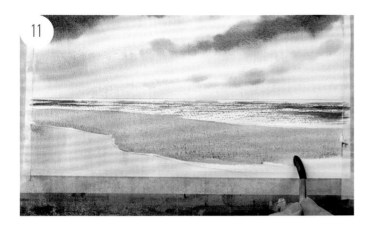

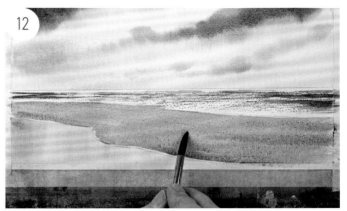

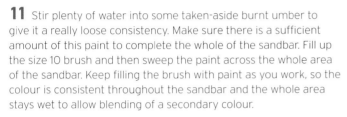

11 Stir plenty of water into some taken-aside burnt umber to give it a really loose consistency. Make sure there is a sufficient amount of this paint to complete the whole of the sandbar. Fill up the size 10 brush and then sweep the paint across the whole area of the sandbar. Keep filling the brush with paint as you work, so the colour is consistent throughout the sandbar and the whole area stays wet to allow blending of a secondary colour.

12 Immediately touch the brush into the warm grey mix and gently sweep in a few horizontal brush strokes, blending them softly into the loose burnt umber base. Repeat this with a touch of loose burnt sienna. This will give the sand form and depth.

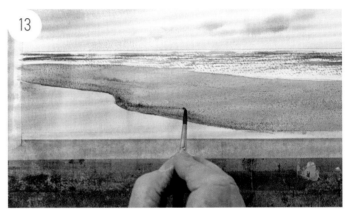

13 While the sand is still wet, pick up a size 6 round brush, dip it into the warm grey mix and quickly but carefully form a sharp line on the bottom leading edge of the sandbar. As you do this, keep pulling the brush up a little to blend into the sand, as pictured, to avoid a solid dark line appearing.

14 Dry the painting thoroughly with a hairdryer, then draw the distant islands and left-hand headland.

15 The far left-hand island is painted with a slightly paler warm grey than the others, to create the illusion of distance. Loosen some set-aside warm grey with a little water. Fill the size 6 round brush with this mix then gently tease it along the left-hand island, working from left to right. Dry this with a hairdryer.

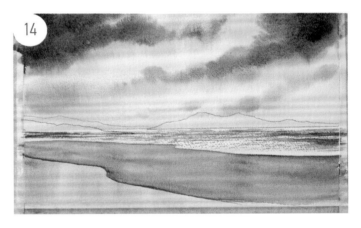

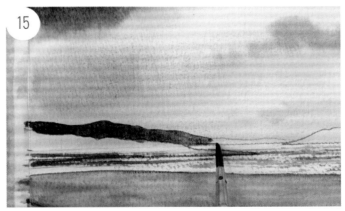

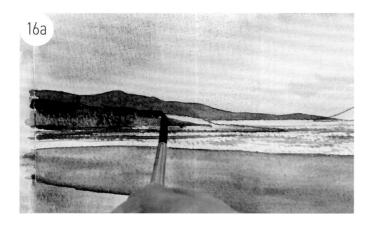

16 Loosen a little of the burnt sienna and run this into the near left-hand headland with the size 6 round. Immediately pick up the stronger warm grey mix and run this along the top edge, allowing it to catch the burnt sienna and bleed down (**16a**). Run a thin line of strong warm grey along the bottom edge of the headland as well; flashes of the burnt sienna should burn through the middle area of the land (**16b**).

17 Paint the island on the right-hand side with a very strong warm grey mix using the size 6 round brush. You can always switch to a smaller brush, such as a size 2 round, to create the sharp point at the extreme end of the island.

18 Draw clusters of rocks on the sand and along the water's edge. If you have any blemishes that you are unhappy with, now is the time to cover them up with rocks!

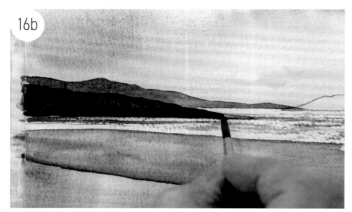

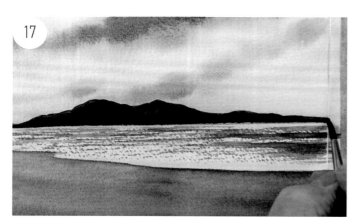

TIP
Whenever painting overlapping features such as the islands in this project, always remember to dry them individually before moving on to the next one to stop them bleeding into each other.

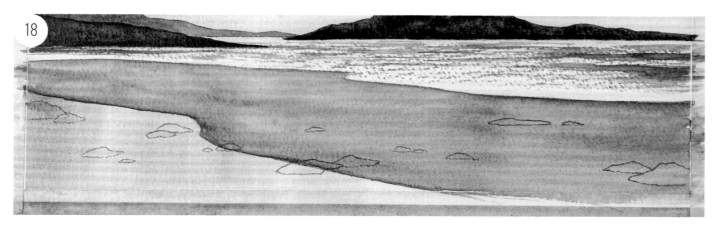

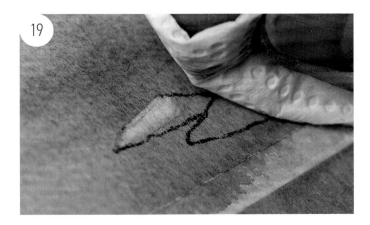

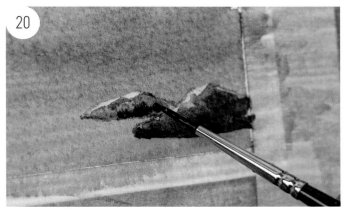

19 Now lift the paint off the top of each stone by scrubbing it with a clean wet 6mm (¼in) flat brush and dabbing with a paper towel. When they are all dry, you can gently erase the pencil marks from the top edges.

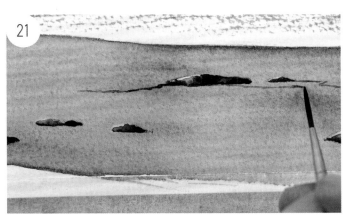

20 Make sure you have two versions of the warm grey mix on the palette – one loose and the other much thicker. With the size 2 round, paint each rock with the loose warm grey mix, leaving a dry white flash at the top edge. Immediately touch some of the darker mix into the base of the rock and allow it to blend.

21 'Connect' some of the rocks with suggestions of seaweed and water-runs in the sandbar, using the size 2 rigger and the strong warm grey mix. You can also paint a few dots here and there to represent tiny stones.

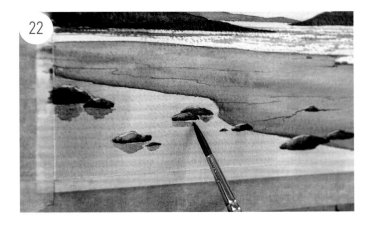

22 Add a pale reflection of each rock standing in the water, using the loose grey mix and the size 2 round brush. There may be a gentle breeze distorting the surface of the water, so the reflections don't need to mirror the rocks perfectly.

23 Add a few birds if you wish (see page 23). Note how I have painted three flying into the painting from the right-hand side; this adds compositional strength by helping to draw the eye in from the outside edges.

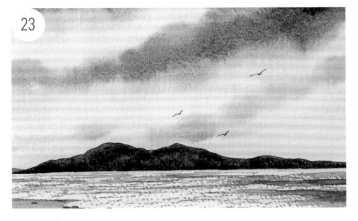

PAINTING DISTANT FIGURES

Draw two carrot shapes where the focal point is (in the case of this project, at the far edge of the sand).
Scrub out the paint inside the figures, following the method described on page 23, using a size 2 round brush (Fig. **1**)
– a smaller brush is best, since the figures are quite small. With a size 2 round brush paint in the jackets, leaving a thin
white glow across the shoulders. I used burnt sienna and burnt umber (Fig. **2**). Then paint the legs, trying to keep them
long and slender – I'm using a thick warm grey mix. If the legs join (as mine do in the right-hand figure) don't worry.
Leaving a tiny gap above the shoulders, paint a dot for each head (Fig. **3**). I used the thick warm grey mix again for this.

24 Add a couple of figures, as described above. The footprints in the sand are optional
but I felt it would help draw the eye to the focal point. If you want to add these, use a
pencil to draw two meandering lines, one from each figure gradually widening towards the
foreground area.

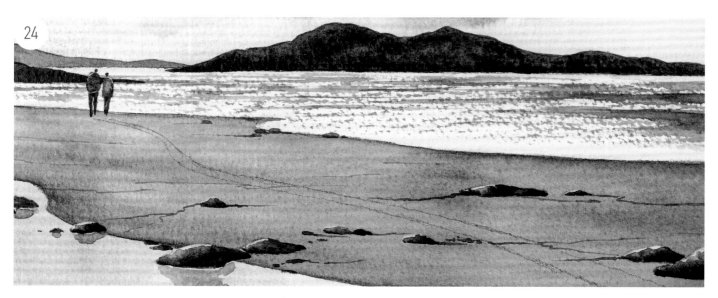

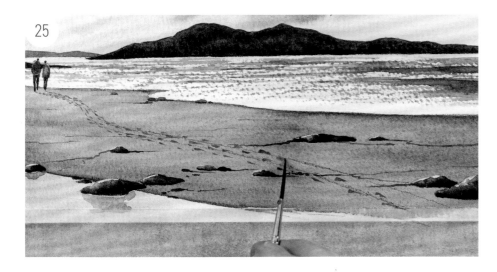

25 With a little of the loose warm grey mix and size 2 rigger, 'flick' in the footprints. There should be two trails from each figure and the footprints should alternate and stagger, to suggest footsteps. They should also be really tiny in the distance then gradually increase in size towards the foreground. Leave the painting to dry, then erase the drawn guide lines.

▼ The finished painting.

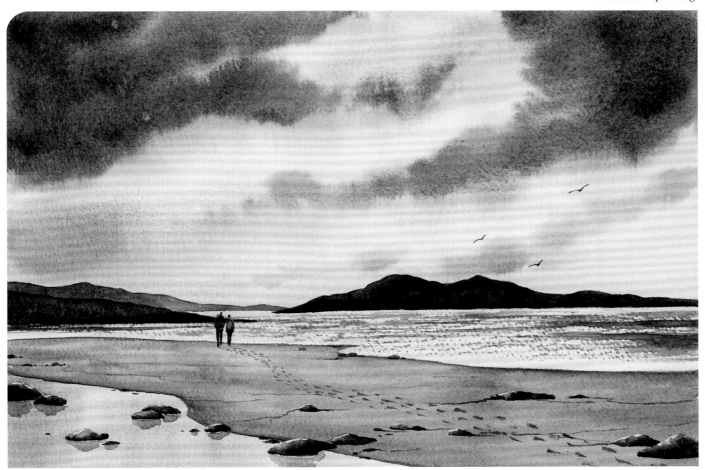

WATER FIVE
Waterfalls and cascading water

There are similar challenges in painting falling water as there are with the sea. There is constant energy and movement, and the impact of a cascade creates white foam just like a breaking wave does.

However, there is one helpful difference and this relates to modern photography. It is most likely that an artist will work from a photograph when it comes to painting cascading water. The majority of photographers will leave the shutter open for a few seconds; the resulting shot captures the moving water, which takes on a blurred, milky appearance while the surrounding stationary features, such as the rocks, remain sharp. This can be seen in the right-hand photograph.

In my view, the blurriness of the water helps the artist a great deal when painting waterfalls. Instead of trying to re-create what would otherwise be troublesome detail, the smoothness of blurred water makes it much easier to represent in watercolour, using a wet-into-wet technique. To create a sharper style of cascading water, a wet-on-dry method would need to be employed. Both techniques are explained on the following pages. The project starting on page 101 employs the wet-into-wet technique (my personal favourite) and is based on the photograph on this page.

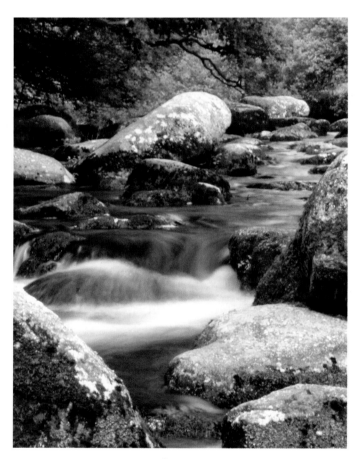

▲ A photograph of a fall in Devon, UK.

A NOTE ON PAINTING FALLING WATER

You will hopefully be familiar with the difference between painting wet-into-wet and wet-on-dry. The two following techniques explore these alternatives so that you can try them both and decide which you are more comfortable with. I would recommend that you try these before embarking upon the project starting on page 101.

For both of the techniques on this page through to page 100, I will be using a warm grey mix for the water and rocks: squeeze out a small blob of burnt sienna and ultramarine; add water to the ultramarine and stir in some of the burnt sienna to achieve a strong mix, the consistency of olive oil.

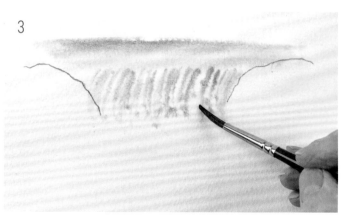

●● TECHNIQUE

FALLING WATER: WET-INTO-WET

This features a waterfall cascading from one level to another through a gap between two rocks. I recommend that you read all the steps carefully before starting, so that you understand the process. It can be hit and miss so be patient and if you get it wrong, don't worry, just keep trying! When it works, the effect is beautiful.

1 To start, draw two curving lines to represent the top edges of some rocks. Then, with a size 6 round brush, sweep several brushloads of clear water in the waterfall area, covering the rocks and working downwards to below the bases of the rocks.

2 Touch the brush into the warm grey mix and gently sweep this across the upper wet area a few times to disperse the colour.

3 Pick up a little more paint on the tip of the brush and create a series of curved stripes, lifting the brush away at random points. The stripes should blur and the bottom of each one will start to disperse into the water on the paper.

4 Pick up a little more of the paint and flick in a few heavier stripes. At this point, if your curved lines are dispersing too much without definition, the warm grey mix is too wet and needs thickening up.

5

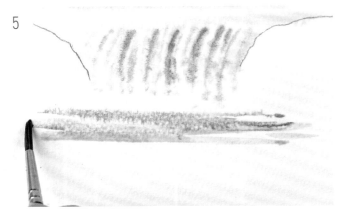

6

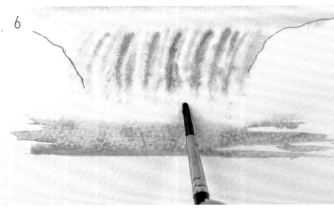

7a

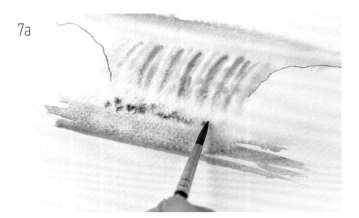

7b

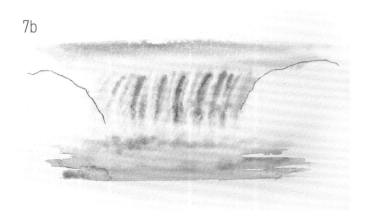

8

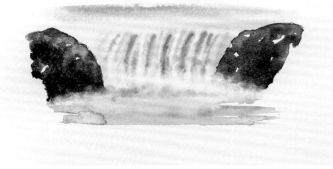

5 Immediately, while the paper is still wet, repeat the same procedure described in step 1 but this time paint across the lower pool area, leaving a clear space below the cascading lines.

6 Once the pool is painted, straightaway wash the brush and gently 'prod' in a little clean water along the white space between the cascading lines and the pool below. This will soften the edges of the paint, and create the illusion of foam. The process is gradual – you may have to wait up to 30 seconds for the softening to take effect – so be careful not to add too much water. If the added water floods and spreads out quickly, dispersing the paint in all directions, you know immediately you have added too much water. If this happens, dab off the whole exercise with a paper towel, dry it with hairdryer and start again. It does require practice.

7 After waiting a few minutes for the softening to take effect, and providing it is all in control and still damp, pick up a little more of the strong warm grey mix and gently prod a line of spots along the lower edge of the foam to give it form and create some shadows (**7a**). Wait a while longer; this added paint should soften a little and disperse (**7b**).

8 Once the waterfall has dried, paint the rocks individually. Run some loose burnt sienna across the rocks, leaving a few dry white flashes here and there. Immediately pick up plenty of the strong warm grey mix and blend it into the lower area of the rocks. Quickly scrunch up a paper towel and delicately dab off the paint at the base of the rocks to create the illusion of rising foam. Magic!

FALLING WATER: WET-ON-DRY

This features a man-made waterfall typically found on rivers. In addition to the strong grey mix, you will need to create a pool of loose grey mix as well as retaining a thicker version. The wet-on-dry method is a little more straightforward and much easier to control.

1

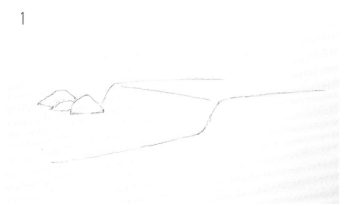

2

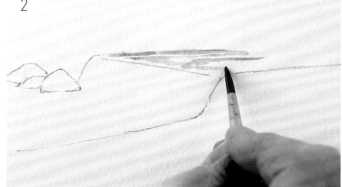

1 Draw two curving lines that form the banks of the river, a line across the head of the waterfall and a few rocks.

2 Fill a size 6 round brush with the loose warm grey mix and run a few flowing horizontal lines across the top section of the river, avoiding the line indicating the head of the waterfall.

3

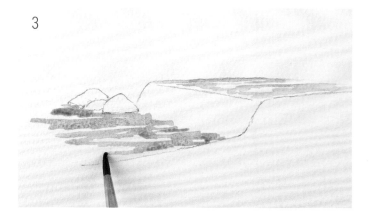

3 Repeat this in the bottom section of the river below the waterfall. Dry the painting with a hairdryer and then erase the pencil line that indicates the head of the waterfall.

4 With gentle strokes, create a series of curving stripes along the length of the waterfall, leaving a few white flashes between them. The brush strokes should start just below where you erased the pencil line, so that you leave a narrow band of white across the top of the waterfall.

4

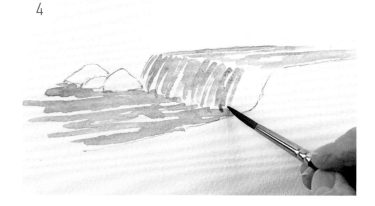

5

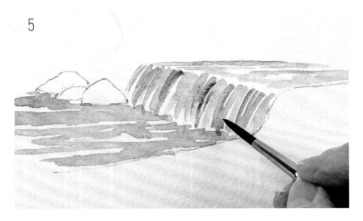

6

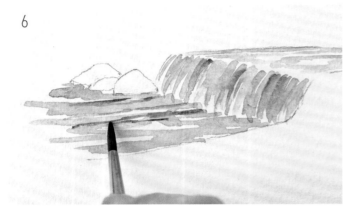

7

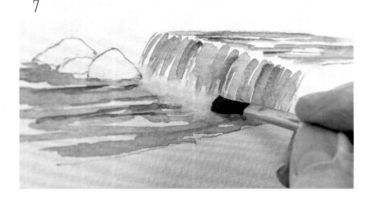

8

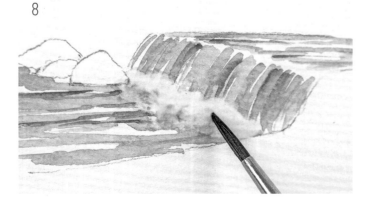

5 While the painting is still wet, flick in a few flashes of the strong warm grey mix.

6 Add a few strokes of the strong warm grey mix to the moving water in the upper and lower areas of the river. Dry the painting with a hairdryer.

7 Fill a 6mm (¼in) flat brush with water and gently scrub across the base of the waterfall with circular movements, to loosen the paint at the bottom of the cascade. Scrunch up a paper towel and then delicately dab the scrubbed area to create a blurry top and bottom edge.

8 With a size 6 round brush, fill this space with a little clean water and then touch in a little of the strong warm grey mix along the bottom edge of the foam to suggest shadows. The grey mix should disperse, but may need teasing a little to help it blend a little more before it dries.

9 If you want to create a finished painting, you can paint some grass along the riverbanks and a few rocks. Prepare a loose light green mix by adding lots of water to some lemon yellow with a little ultramarine (see the left-hand mix in the palette, opposite), and a dark green mix by combining lemon yellow with more ultramarine (see the right-hand mix in the palette, opposite). Flick the brush around the riverbanks with the loose light green mix first, then while this is still wet, drop in some of the darker green mix here and there. For the rocks, paint them in the same way described in step 8 on page 98.

9

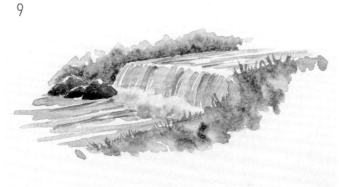

MOORLAND FALLS

<div style="border: 1px solid;">

You will need

Brushes: size 6 round, 6mm (¼in) flat, size 2 rigger

Paints: ultramarine, lemon yellow, burnt sienna, burnt umber

Paper: 33 x 23cm (13 x 9in) of 300gsm (140lb) NOT, such as Bockingford

Extras: masking tape, pencil, soft eraser, paper towel, hairdryer

</div>

1 MAKING A DRAWING: Draw in a rocky falls scene, referring to the photograph on page 96. The position of all the rocks should be carefully drawn first. Note the two rocks in the centre, where the stream drops, do not have a base line. This is where the water will be foaming, and pencil lines here may be difficult to erase later.

2 PREPARING THE PALETTE: The palette should be prepared in two stages. First, squeeze out two small blobs of lemon yellow and a single blob of ultramarine. Stir plenty of water into the first blob of lemon yellow and then add a touch of ultramarine to produce a loose light green. Do the same with the second blob of lemon yellow but with a bit less water and more ultramarine.

3 Fill the size 6 round brush with the loose light green and 'prod' it gently into the background woodland space behind the rocks, leaving a few white flashes of paper. Revisit the palette many times as you paint this area, to keep the brush full and to ensure a good spread of wet paint.

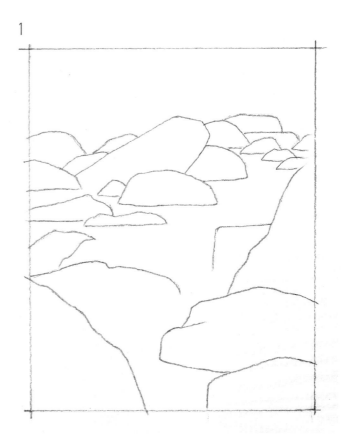

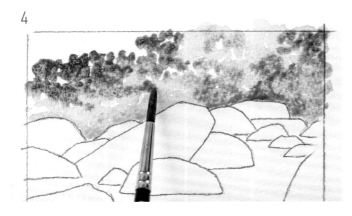

4 Immediately fill the brush with the darker green mix and use the same prodding action to add areas of contrast to the background woodland. The two shades of green should suffuse and soften significantly, providing the first coat of the light green is wet enough.

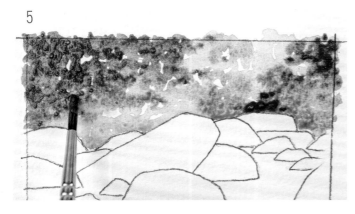

5 Keep adding more of the dark green, focusing on the top left-hand corner. Add a few touches to the right-hand area, just above the rocks.

6 The whole stream, from top to bottom and including the waterfall, is painted wet-into-wet; this means all the stages required to paint it should be completed before it dries. I recommend that you read steps 6–11 carefully before starting.

Squeeze out a small blob of ultramarine and burnt sienna. Stir some burnt sienna into the ultramarine until you have a grey mix, then add water to this mix until it's the consistency of olive oil. Place some of this grey mix onto a clean part of the palette, or into a separate well, and stir in some water to make a loose version of the grey mix.

With the palette ready, fill the size 6 round brush with water then sweep it across the area of the stream. Wet from where the stream starts down to the tops of the lower rocks. You will need to fill the brush several times, and keep spreading out the water, so the whole area is thoroughly wet.

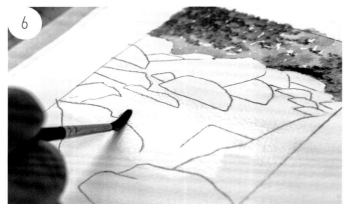

7 Touch the tip of the brush into the loose grey then sweep a few lines of this into the upper stream. Repeat this quickly with a touch of the stronger grey mix. Don't avoid the rocks: draw the mix straight through them.

8 Pick up a little more of the loose grey mix on the tip of the brush and create a series of curved stripes where the stream drops, lifting the brush away just above the lower rock. Immediately pick up a touch of the stronger grey mix and flick in a few darker lines. All the stripes should start to blend into each other.

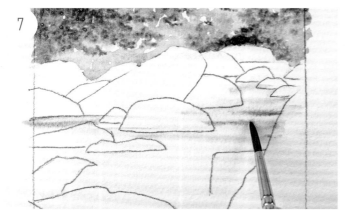

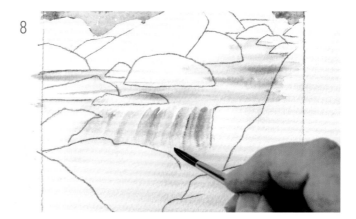

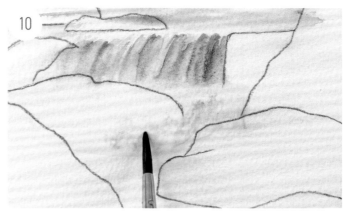

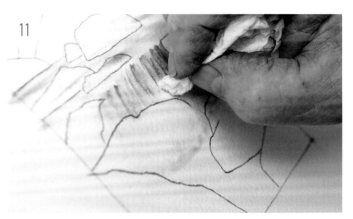

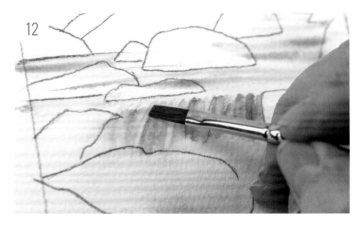

9 Immediately, wash out the brush and fill it with clean water. Paint this water across the top of the rock, ensuring it comes into contact with the bottom of the waterfall lines. This water should seep upwards and start to react with the waterfall lines, causing them to blur.

10 Now touch a little of the loose grey mix into the lower area of the foam; this should also blend into the water and create a blurred effect.

11 Scrunch up a paper towel and hold it so that there is just a narrow tapered bit protruding from your fingers. Very delicately prod this along the lower edge of the waterfall lines to remove a little paint and create the effect of a foaming edge. There is a possibility that you won't need to do this. Sometimes the movement of the added clear water will behave perfectly and give you the desired result without any further interference. When you're happy with the result, dry the painting with a hairdryer.

12 This stage is optional. If your cascade is lacking white spaces, it is possible to create a few by lifting them out. Use a wet 6mm (¼in) flat brush to scrub away a few curved lines then dab away the paint with a paper towel.

13 To complete the stream, wet the whole lower area again and repeat the process described in step 7.

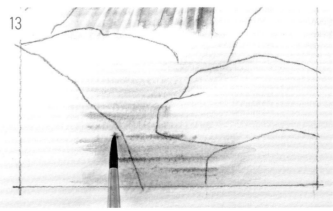

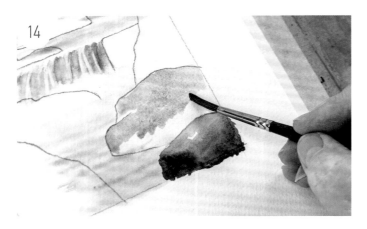

14 The rocks should all be painted using the same method, with the exception of the two at the base of the waterfall. Each rock is lighter at the top and becomes darker lower down, where there is less light. It is preferable to overlap the rocks, starting in the foreground. You will need plenty of loose burnt umber for the base colour, some loose burnt sienna and a good supply of the strong grey mix. The rock in the foreground should be painted first using the method described here. First, cover the whole area of the rock with plenty of loose burnt umber, leaving the occasional flash of dry white paper.

15 Immediately flick in some burnt sienna here and there, allowing it to blend into the burnt umber.

16 If you have some green left from earlier, try flicking in a little of that to suggest some moss on the rocks.

17 Don't wash the brush; instead, pick up plenty of the strong grey mix and start brushing it into the central areas of the rock.

18 Now plunge the brush into the strong grey again and touch it into the lowest part of the rocks, guiding the brush round the top edge of the rock in front. This dark paint should provide definition and contrast between each rock. Let the paint develop for a minute or two then dry it with a hairdryer.

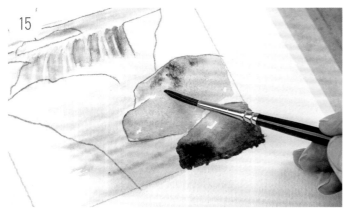

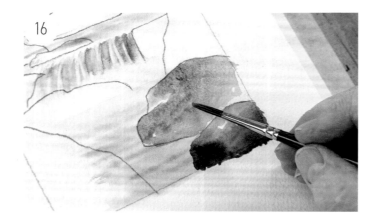

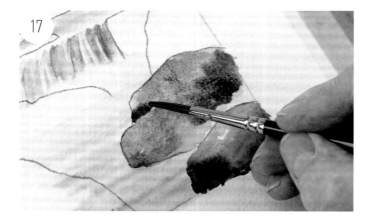

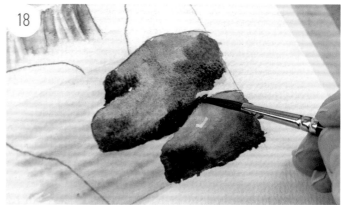

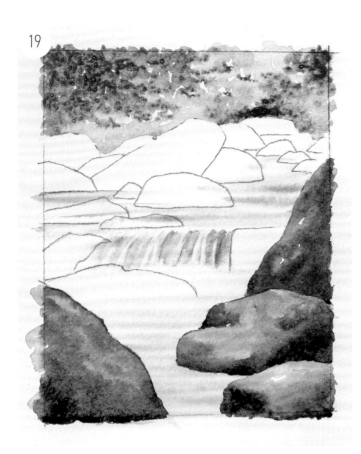

19 All the foreground rocks should be completed first.

20 Water is bubbling round the base of the central rock in the stream. Paint it just like the others, but this time tease the lower dark grey paint down into the white space at the base of the rock.

21 Immediately run a little clean water across the white space, allowing it to touch the dark paint you have just applied. It should start to run a little. Now follow the same procedure described in step 11 with some paper towel.

22 Keep dabbing gently until the rising foam looks perfect.

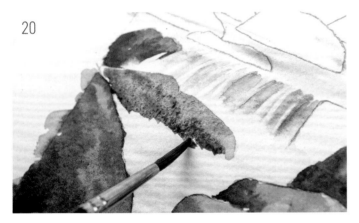

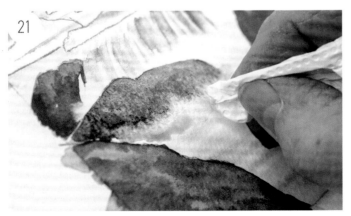

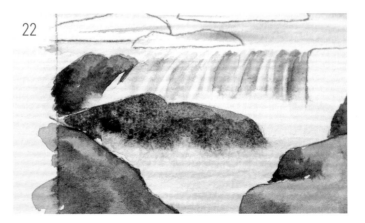

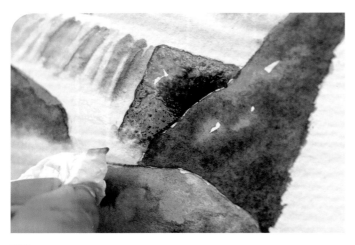

23 Paint the rock on the right-hand side of the cascade then use the same method described in step 21 to lift out a little paint at the base of the rock, to create the rising foam.

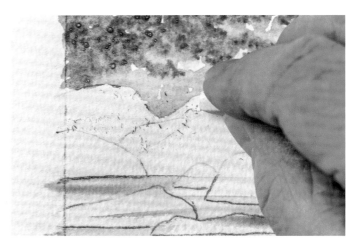

24 So pencil lines aren't visible at the end of the painting, I recommend lightening them with an eraser.

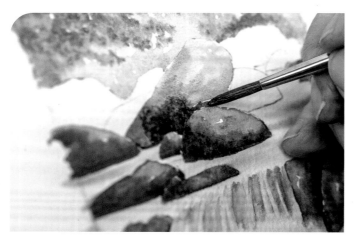

25 Continue painting the rest of the rocks in the scene in the same way as before, working from the foreground rocks backwards and drying each one with a hairdryer when you complete it, to prevent the colours bleeding into each other.

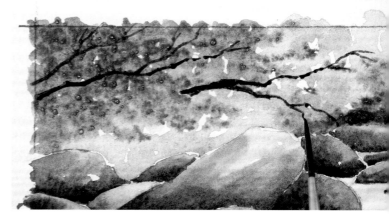

26 To finish off, use a size 2 rigger and the strong grey mix to create a few overhanging branches.

▶ **Opposite:** the finished painting.

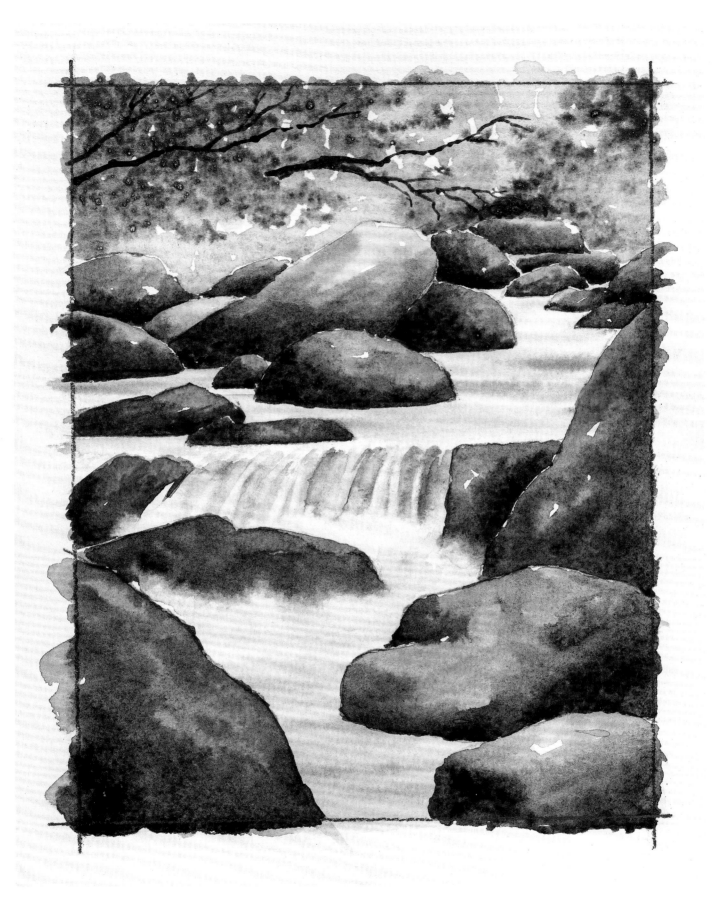

Water droplets

A few years ago I was out in my garden and came across a completely unexpected idea for a painting study. The sun was shining but there had been a sprinkle of rain beforehand, leaving a few raindrops scattered on the leaves. What was particularly interesting about them was the shadow they cast onto the leaves, even though water is completely transparent. The dark shadows on the leaves, coupled with the reflecting light on the raindrops, were so dramatic that I decided to study them to see if I could replicate the effect with watercolour paint. I took some photographs and set to work.

THE THEORY

In the bottom-left photograph, there are some important features to observe. First, the shadows cast by the water droplets are really dark. Second, there is a bright pin-sized spot of light on the left-hand side of each droplet; this is actually the direct reflection of the sun itself. Third, if you look carefully, you will see that there is a curious and unexpected change in the colour of the leaf across the width of the water droplet. Allow me to explain.

The sketch in Fig. **a** features a solid sphere such as a pebble. There is a strong source of sunlight from the left-hand side that gradually diminishes across the curved face of the pebble, just as you would expect. The direct sunlight casts a dark, crescent-shaped shadow to the right, and has a distinct sharp edge.

The sketch in Fig. **b** features a water droplet similar to those seen in the photograph. The transition of light, from one side to the other, is almost the opposite to that of a pebble. That is, the darker part is to the left and facing the light. Despite this, the shadow cast to the right is the same as that for a solid object. In this study, I realized that all this must be caused by the way light refracts through the water. The reflection of the sun, in the pin-sized spot, is on the left-hand side where it would be expected. This is very convenient because the tone of the water droplet is darker at this point, which helps the reflection to stand out. I knew from the outset that this spot of light would be crucial in the painting study.

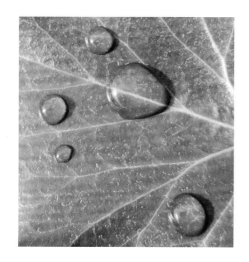

a
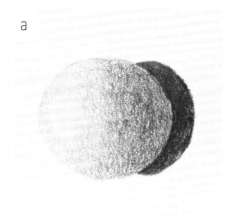

b
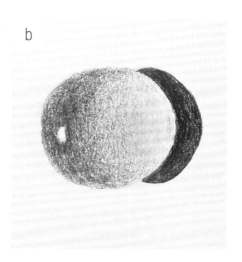

OAK LEAVES

You will need

Brushes: size 2 round, size 8 round, size 2 rigger

Paints: ultramarine, lemon yellow, burnt sienna

Paper: 20 x 16cm (8 x 6in) 300gsm (140lb) NOT,
such as Bockingford

Extras: masking tape, pencil, soft eraser, paper towel,
hairdryer, chosen white medium (I'm using permanent
white gouache, but you could use white calligraphy ink,
white acrylic paint or a white gel pen)

1 MAKING A DRAWING: Draw the outline of two oak leaves that join into a single stem. In addition, draw a line down the centre of each leaf.

2 PREPARING THE PALETTE: Squeeze out two small blobs each of lemon yellow, ultramarine and burnt sienna, keeping them apart on the palette. You should have six separate blobs of paint. Add plenty of water to one of the blobs of lemon yellow and add a little ultramarine to create a loose light green. Add water to the other blob of lemon yellow, adding less than before so it is thicker. Keep adding ultramarine to this second mix to create a dark green. Now combine the second blob of ultramarine with one of the blobs of burnt sienna to create quite a thick, strong, warm dark grey.

3 Using a wet size 8 round brush and plenty of the loose light green mix, paint the left-hand leaf. Keep the angle of the brush low so that more of the hair is in contact with the paper, and use only a gentle touch to allow the paint to flow out more readily. You may need three or four brushloads of paint to make sure it is evenly wet across the whole leaf.

4 Immediately pick up some of the dark green and flick the brush here and there into the light green. You need to make this application quite patchy, so the two mixes blend and create a soft, variegated green wash.

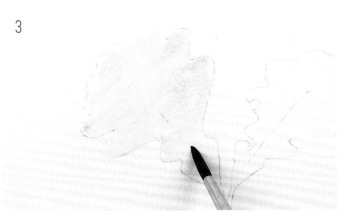

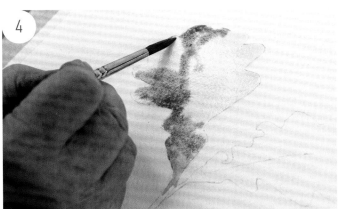

5

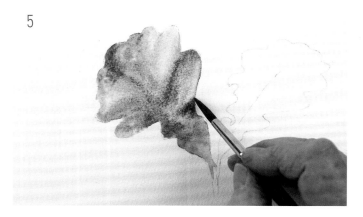

5 The paint should start to granulate as it settles. Keep adding more of the dark green to the edges of the leaf, and then create a few radial marks that run from the outer edges of the leaf towards the central line. As these additions settle, they should give the impression that the leaf has an undulating texture. Leave the paint to develop, and refrain from fiddling with it further.

6 Follow the same procedure with the right-hand leaf.

7 Add plenty of water to the remaining blob of burnt sienna. Use this and the size 2 round brush to paint the stem, then immediately run a couple of lines of the dark grey mix down the stem to give it some form.

8 Very slowly run a clean, wet size 2 rigger along the central line of each leaf. Immediately dab both the lines with a paper towel; you should be left with thin white lines.

9 With the loose warm grey mix and the size 2 rigger, paint a few curving veins on the leaves that radiate outwards from the central line. Thoroughly dry the painting with a hairdryer.

6

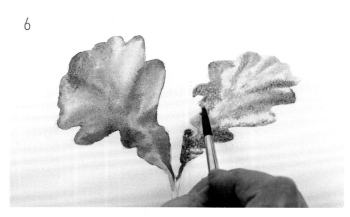

7

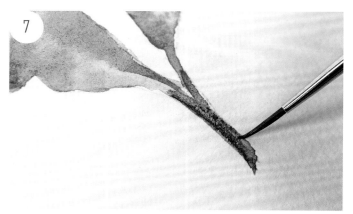

8

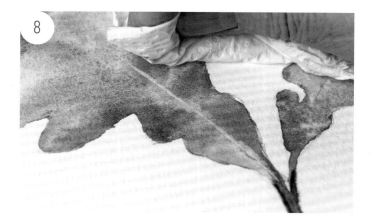

9

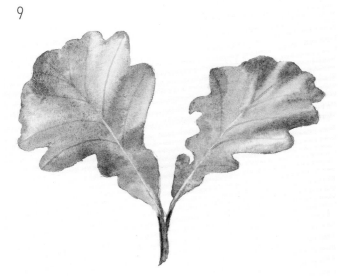

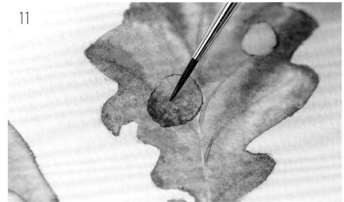

10 Draw a few small circles onto the leaves with a pencil. Vary the shape and size of them, and arrange them so there is a different number of droplets on each leaf. Fill the size 2 round brush with clean water and gently 'scrub' the paint in one of the circles until it becomes loose again. Then give it a quick dab with a paper towel to remove all the paint. You should end up with a clear white space. Do this with all of the water droplets.

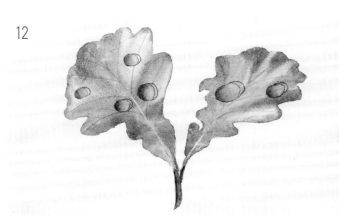

11 With the same brush, fill the entire area of a water droplet with some of the loose light green mix. Immediately paint the left-hand edge with a little of the dark green mix and then 'scribble' the brush gently to encourage the dark green to blend into the lighter green. It is important that this doesn't travel all the way across to the right-hand side, so take care not to add too much of the darker green. If this does happen, dab it all off with a paper towel and then try again.

12 Complete the remaining water droplets in the same way then dry them with a hairdryer. Next, for the shadows, draw a crescent shape on the right-hand side of each droplet.

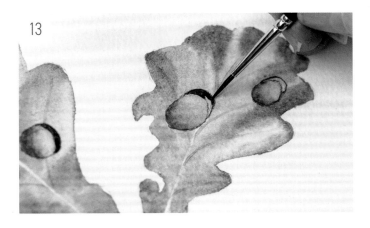

13 With the size 2 round brush and strong warm grey mix, carefully fill in the crescent shapes.

14 Until this moment, the water droplets are pretty unconvincing. All that remains is a white dot to create the pin-sized reflection of the sun. I am using permanent white gouache for this; however, it is possible to use white acrylic paint, white calligraphy ink or even a white gel pen to create the light spots as an alternative to gouache.

Squeeze out a tiny amount of the gouache onto your palette. Dampen the size 2 round brush and pull it through your fingers to sharpen the tip. Pick up a tiny spot of the gouache on the tip of your brush then gently touch this into the left-hand side of a droplet. Suddenly, you have water! Repeat with the remaining water droplets.

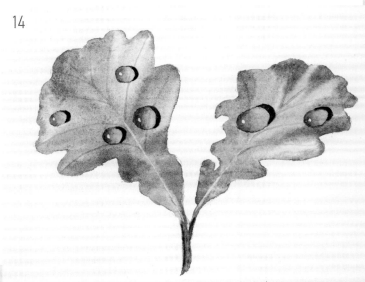

Index

beach 29, 47, 48, 50, 51, 60, 62, 64, 65, 66, 70, 72, 77-83, 85, 87, 88-95

bird(s) 8, 23, 29, 39, 71, 83, 87, 93

blend(ing) 14, 16, 17, 26, 38, 40, 44, 45, 46, 56, 64, 65, 66, 67, 68, 69, 74, 75, 76, 78, 81, 91, 93, 98, 100, 102, 103, 104, 109, 111

boat(s) 13, 16, 62, 50-71

brush(es) 15, 18-22, 59
- flat brush 18, 22, 23, 34, 56, 57, 60, 77, 86, 88, 100, 101
- hake (medium or large) 7, 18, 22, 26, 34, 41, 77
- mini hake 18, 22, 33, 38, 52, 60, 77, 86, 88
- rigger 19, 23, 29, 34, 41, 60, 77, 86, 88, 101, 109
- round brush 19, 17, 21, 34, 41, 52, 56, 57, 58, 60, 73, 74, 77, 85, 86, 88, 94, 97, 98, 99, 100, 101, 109
- Scimitar 19, 34, 38

cloud(s) 8, 12, 16, 32, 34, 35, 42, 72, 78, 84, 88, 89, 90

colour(s) 12, 26, 32, 34, 50, 51, 58, 72, 108
see also paint(s)

conditions, water 6, 9, 10, 11, 12, 13, 32, 40, 41, 52, 72, 84, 93, 96
see also reflection(s)
- foaming 23, 72, 73, 74, 75, 82, 96, 98, 100, 101, 103, 105, 106
- rippling 10, 12, 13, 32, 37, 40, 41, 49, 50, 52, 57, 84
- shining 7, 12, 33, 35, 50, 65
- sparkling 12, 84, 88
 see also dry-brush
- wave(s) 11, 72, 73, 74, 75, 79, 80, 82, 83

consistency 16, 17, 23, 76, 88, 97

dip pen 27, 59, 77, 83

drawing(s) 29, 34, 37, 41, 44, 47, 52, 54, 55, 60, 69, 70, 73, 74, 75, 77, 88, 90, 91, 92, 94, 97, 99, 101, 109, 111

dry-brush 21, 25, 47, 85, 86, 87

eraser 27, 34, 52, 59, 73, 74, 88, 101, 106, 109

figure(s) 8, 29, 88, 94

finished paintings 7, 9, 29, 30, 31, 32, 39, 49, 51, 55, 71, 72, 76, 83, 95, 107, 110

gouache 21, 29, 73, 75, 76, 77, 109

granulation 14, 25, 85, 89, 110
see also paint(s)

grass(es) 19, 32, 38, 100

hairdryer 15, 26, 27, 34, 41, 52, 56, 57, 59, 60, 74, 75, 77, 86, 88, 98, 99, 100, 101, 109

headland(s) see landform(s)

island(s) see landform(s)

lake(s) 7, 9, 12, 32-49, 50, 72

landform(s) 32, 34, 35, 36, 37, 41, 45, 46, 47, 52, 53, 60, 87, 88, 91, 92

lifting out 7, 18, 23, 56-57, 62, 67, 69, 74, 80, 86, 90, 91, 92, 93, 94, 100, 102, 103, 106, 111

masking fluid 27, 51, 56, 59

masking tape 26, 34, 41, 44, 45, 52, 60, 77, 86, 89, 101, 109

mixing 17, 33, 34, 42, 45, 52, 61, 73, 74, 75, 76, 77, 79, 82, 86, 87, 88, 97, 101, 102, 109

negative painting 58, 75, 87, 90, 93

paint(s) 8, 16, 17, 26, 32, 33, 41, 50, 52, 56, 60, 73, 74, 75, 77, 86, 88, 97, 101, 109

photograph(s) 2, 10, 11, 12, 29, 41, 50, 84, 88, 96, 108

reeds see grass(es)

reflection(s) 6, 7, 9, 10, 11, 12, 13, 16, 23, 29, 32, 37, 44, 45, 46, 48, 50, 51, 52, 54, 55, 56, 57, 58, 59, 62, 69, 70, 72, 84, 90, 93, 108, 111
- blurred 12, 13, 32, 40, 41, 52, 53, 79, 93, 96, 100, 103

rock(s) or stone(s) 48, 60, 66, 70, 77, 79, 80, 81, 82, 83, 90, 92, 93, 97, 98, 99, 100, 101, 102, 103, 104, 105, 106, 108

ruler 27, 34, 40, 41, 47, 51, 52, 54, 56, 60, 69, 76

sandpaper 27, 40, 41, 49

sea 9, 11, 26, 29, 32, 51, 60, 63, 66, 72-83, 86, 87, 88, 90, 96
- marbling 72, 74-75, 82, 83
- spray 75, 76, 83

scrub(bing) see lifting out

technique(s) 17, 20, 21, 22, 23, 33, 38, 40, 51, 56-57, 58, 59, 60, 73, 74-75, 76, 85, 88, 94, 97-98, 99-100

time or timing 8, 14, 15, 16, 25, 42, 45, 59, 77, 78, 86, 89, 98, 104

toothbrush 76
see also spray under sea

tree(s) 9, 32, 46, 47, 101, 102, 106

watercolour paper 15, 17, 23, 24-25, 26, 34, 38, 41, 42, 51, 56, 60, 63, 73, 74, 77, 85, 86, 88, 101, 109

waterfall(s) 96-107

wet-into-wet 12, 13, 16, 17, 33, 34, 35, 40, 41, 42, 43, 44, 45, 46, 47, 52, 53, 56, 57, 58, 59, 61, 62, 64, 65, 66, 67, 73, 75, 77, 78, 79, 80, 81, 86, 89, 90, 91, 92, 96, 97-98, 102, 103, 104, 105, 106, 109, 110, 111

wet-on-dry 13, 21, 36, 37, 38, 47, 48, 53, 54, 55, 57, 58, 59, 66, 68, 69, 70, 71, 74, 79, 80, 82, 87, 90, 91, 92, 93, 94, 95, 96, 97, 99-100, 101, 106, 111